Acknowledgements

Photography: Jeffrey B. Snyder
Sculpture cleaning and photo editing: Ginger Doyle
Editor: Dinah Roseberry
Special thanks to Peter B. Schiffer for the use of his warehouse and a big pile of dirt to play in.

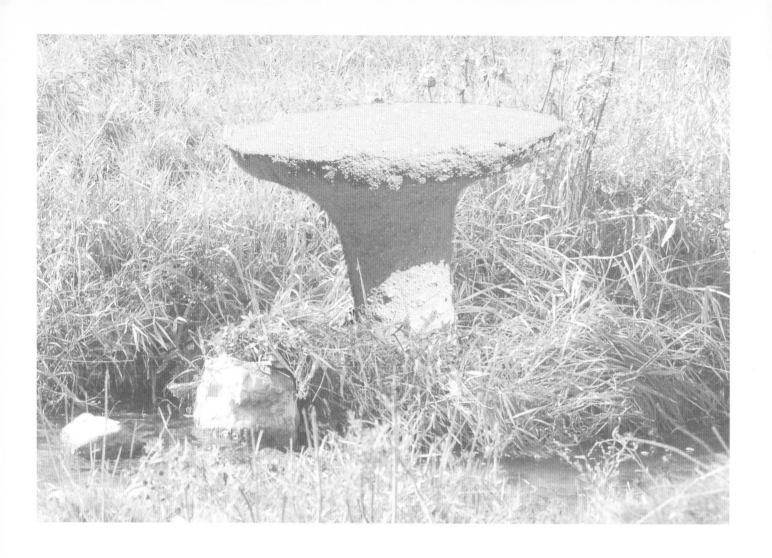

Contents

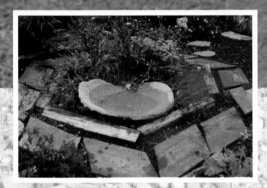

Sand-casting Concrete

Five Easy Projects

Tina Skinner

Bo Atkinson

Jeffrey B. Snyder

Schiffer Publishing Ltd®

4880 Lower Valley Road, Atglen, PA 19310

Schiffer Books are available at special discounts for bulk purchases for sales promotions or premiums. Special editions, including personalized covers, corporate imprints, and excerpts can be created in large quantities for special needs. For more information contact the publisher:

Published by Schiffer Publishing Ltd.
4880 Lower Valley Road
Atglen, PA 19310
Phone: (610) 593-1777; Fax: (610) 593-2002
E-mail: Info@schifferbooks.com

For the largest selection of fine reference books on this and related subjects, please visit our web site at

www.schifferbooks.com
We are always looking for people to write books on new and related subjects. If you have an idea for a book please contact us at the above address.

This book may be purchased from the publisher.
Include $3.95 for shipping.
Please try your bookstore first.

You may write for a free catalog.

In Europe, Schiffer books are distributed by
Bushwood Books
6 Marksbury Ave.
Kew Gardens
Surrey TW9 4JF England
Phone: 44 (0) 20 8392-8585; Fax: 44 (0) 20 8392-9876
E-mail: info@bushwoodbooks.co.uk
Website: www.bushwoodbooks.co.uk
Free postage in the U.K., Europe; air mail at cost.

Designed by Ro Shillingford

Type set in Humanst521 BT/Zurich BT

ISBN: 978-0-7643-2867-1
Printed in China

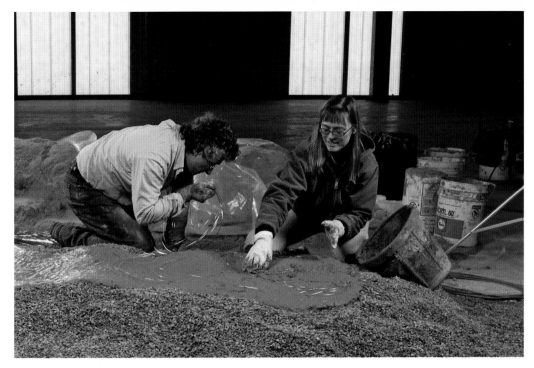

This is fun! Author Tina Skinner and craftsman Bo Atkinson play in a pile of gravel, casting a concrete bench.

Introduction

The purpose of this book is to demonstrate the possibilities of playing with concrete. Sand-casting concrete is a free form of expression, an opportunity to hand mold and sculpt a work that expresses *you*. Like working with children's clay, or building a sand-castle, it's a form of play that allows you to create as you go, and to have fun with the process of art.

In our case, we worked on a large scale, casting big garden ornaments into truckload piles of sand and gravel. At home, you might do this in a compost heap, or in a pile of dirt. On a small scale, you could simply fill a cardboard box with sand and work in the garage to create small ornaments, stepping stones, statues, or whatever the muse moves you to do. Pile some dirt in the garden where you want your final sculpture to stand and build it right there. Concrete is heavy—you don't want to have to transport your finished sculpture far if you don't have to.

To make this book, we put our piles of sand and concrete in our unheated warehouse in Pennsylvania so we could work in the middle of frigid January weather. Without running water, we worked with a barrel half filled with water to provide both water for mixing, and a source for cleaning our tools.

Every area has its own sands. Bo found ours particularly special, wishing he could take it home with him. A passenger car and a ten-hour drive back to Maine convinced him to settle for a small glass jar as a memento.

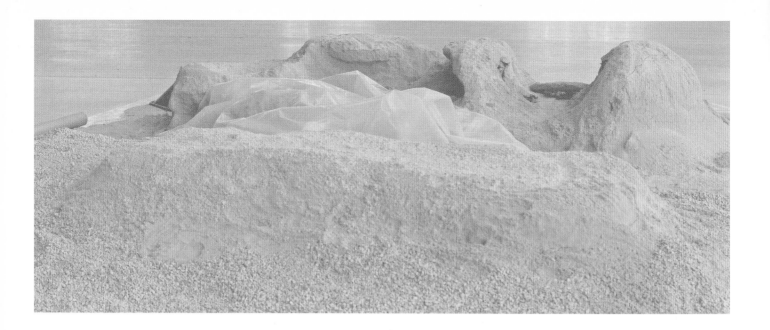

Concrete sets slower under these conditions, so we covered our work with sand and plastic and allowed it to incubate for weeks as opposed to hours and days. Toward that end, this book simply documents Bo Atkinson at play. Faced with the directive of making several sculptures for a garden setting, he set out with a blank canvas, or in this case, pure piles of sand and gravel. We ended up with a wonderful assortment of very organic-looking, whimsical garden sculptures.

At the end of the day, it's all about practice. You need hands-on experience to get a sense of how the concrete mix should feel as you add water to get the right consistency. You'll find ways of creating steel and fiber reinforcement appropriate to the scale of your work, and you'll develop techniques for shaping your work and finishing it to your liking.

The first and most important step, though, is buying your first bag of concrete and getting to work! Pick up that first heavy bag of concrete and open it. Pile up some tools, have a bucket of water handy, and get started.

If you don't work out every day, be sure to work into a project like this with small steps. This is really strenuous work. You might want to wear a back belt to make sure you aren't disabled the day after. And remember, a project as big as a bench can be built in stages, put down a wet coat, cover it with plastic, and come back the next day and make another layer with a wet mix. If it's really hot, make sure to work in the shade, under a tarp, or in a tent to keep your project from curing too fast.

Weather is no excuse if you're willing to tough it out. Hang a tarp in the trees if you want to work in the rain, or if you want to create a shady spot and ensure that the sun doesn't shine directly on your project as it cures.

Remember, failure is only as bad as the effort to get the ugly or broken pieces to the curb, or to use them as fill for that unsightly hole in the back forty. You still get to keep the exercise gained, the fun had, and the lessons learned.

Tools We Needed

A hand-held concrete mixer is a handy tool to have. This bucket of concrete weighs in excess of seventy-five pounds, so you want to restrain yourself when adding material!

Welding wire (also called MIG wire; it is made of copper coated steel)

2 tons sand

2 tons gravel

Cement

PVA fibers (see Reinforcement section)

Steel reinforcement rods

Various tools; shovel, rake, old kitchen knife

Barrel half filled with water

Bucket for mixing in

Scoop for transporting water

Spray bottles

Fresh or dried leaves

Sponge for texture

Wire snips

Pigment

Acid stain

Muriatic acid or hydrochloric acid to clean up any stains inadvertently dropped on surfaces

Plastic sheet

For Safety's Sake

Gloves and a mask are essential to protect yourself from the inevitable dust in cement. Cement, although not lethal, is certainly not something you want to breathe, let alone get in your eyes. It contains silica, a known lung irritant. **Don't breathe the dust!**

Unless you're a regular at the gym, you should wear a back belt for the heavy lifting of cement, sand, gravel, and the whole mix. Wear latex or rubber gloves to protect your skin—concrete is very drying, and can irritate small cuts and scratches. Moreover, use earplugs if you're using an electric mixer.

The Mixes

The following are rough guidelines for the mixes we used in our projects. Each was mixed using small portions, built up in the bucket as we mixed. Using small amounts helps to better incorporate the ingredients. Water portions vary depending on weather conditions—less is needed in humid conditions, more on a hot day. It's very much a matter of experience and feel. Put on latex or rubber gloves and get your hands into the mix. Learn how it feels, and how it should feel. Remember, you're not pouring a sidewalk. You're creating. Some potters like their clay wet, others dry. You'll find the consistency that's right for you, and that works for what you want to build.

Ferro cement is a lightweight formula, created without gravel. It's thin bodied, and needs to be reinforced using steel. The idea is to integrate the steel into the cement. We are duplicating on a small scale what contractors do when they build large, architectural structures reinforced with steel bars and beams. You want to pack in quite a bit of steel. The overall thickness will be about an inch at the thinnest spots. The challenge is to incorporate as much steel as you can, but to completely encapsulate it in the concrete mix.

Ferro Concrete Mix:

2 pts. Sand
1 pt. Cement
Handful PVA (roughly 1/8 volume of cement)
Water

Wet Mix:

1 part Sand
1 part cement
1/2 part gravel
Fiber

Recipe for Heavy Cement Mix:

1 Parts Cement
2 Parts Gravel
2 Parts water

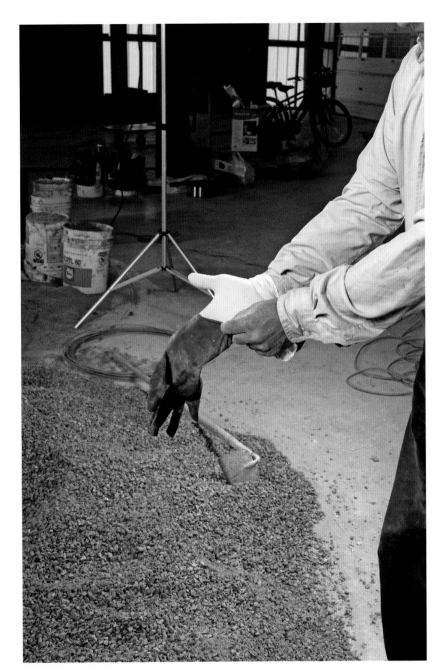

Using a thin latex liner will help extend the usefulness of a sturdy pair of latex gloves when they start to get small holes or tears.

Extra Rich Mix

1 1/2 parts Concrete
2 parts sand
2 parts gravel
Lots of both long and short fibers

Rich mix is a thick, sticky mix. Another option is to use lime-based cement mix, called masonry light, composed of Portland Type I and Lime.

Grout Mix

1 pt cement
1 pt. Sand
Lots of fiber

Before mixing his concrete, Bo creates ready-to-use pieces of welding wire. Each hoop contains 7-10 loops of welding wire. These are stored on a notched stick until he needs them. Preparing a dozen or more coils in advance will save time later, and keep them handy. Coils can be stored on a length of cedar branch or 2 x 2. Make angled notches with a carpentry blade or circular saw. The notches save having to tie off the coils.

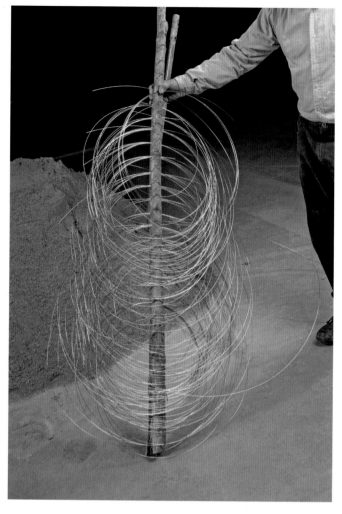

Reinforcement

Bo has developed his own technique using welding wire. The wire offers high tensile strength and is available wherever welding supplies are sold. It costs roughly fifty cents a pound. You can buy a spool for $15 or so. It is steel with copper coating, which provides corrosion prevention.

You could also use galvanized wire. It is generally soft; not as strong.

The goal with any metal reinforcement is to completely encapsulate it within the concrete. Water content becomes chemically bound within the concrete and protects the wire from corrosion. Also, rust needs room to grow and is too constricted once set inside the concrete.

Most concrete work involves the use of various wire meshes and bar. Bo detests mesh. "A lot of concrete workers work with wire mesh with many cut edges. If you ask them, they've always got cuts and scratches. I don't have that problem using the wire."

In many of his mixes, Bo incorporates PVA (polyvinyl alcohol) fibers. This fibrous, lightweight material adds a lot of strength to a finished project. This is an art, and measurements are subjective. However, once again, you want to incorporate the fibers into the mix. A drawback of these fibers is that they can create a peach-fuzz like surface to the final product. The cure for this is to use a blowtorch to burn away the exposed fibers.

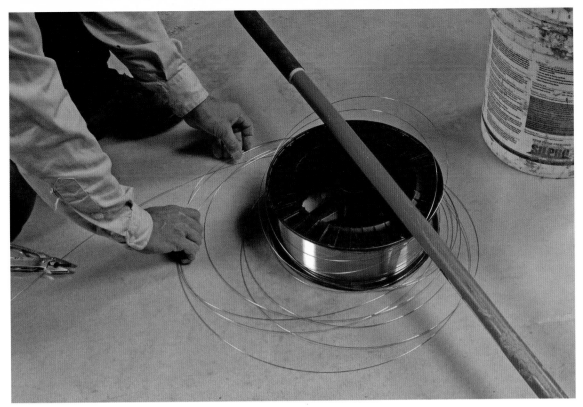

Welding wire is stiff and springy and is often difficult to control. Several simple techniques will help you control the wire. Bo shows how he gets the wire off the spool. Work close to a wall, bucket, or tree to contain the dimension of the wire as it uncoils. The shovel handle keeps the wire from leaping over the top of the spool.

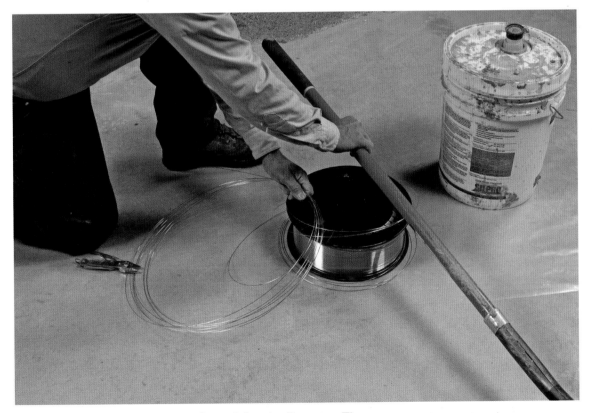

Remove coils of 7-10 loops, about 2 feet in diameter. The shovel handle is lifted to allow separation of the new hoop.

The Concrete

In cold weather cement can get lumpy, which can reduce the overall strength of the sculpture. This is hard to avoid. Suppliers often accidentally punch holes in the plastic lining of the bags, admitting moisture, and making the lumps. If you cannot break the lumps easily with your fingers, don't use it! We rejected several bags of ruined concrete, and did our best to pick out the lumps.

A handy way to open the bag is to cut it right down the middle, lift it up and it will split in half. As soon as you open it up it will start to admit moisture. If you'll only be using a little, store it in a closed container.

We are working with two piles of sand and gravel, which are widely available for local delivery. These materials are sold by the ton or the cubic yard. This shipment cost $260 for one delivery of a "split."

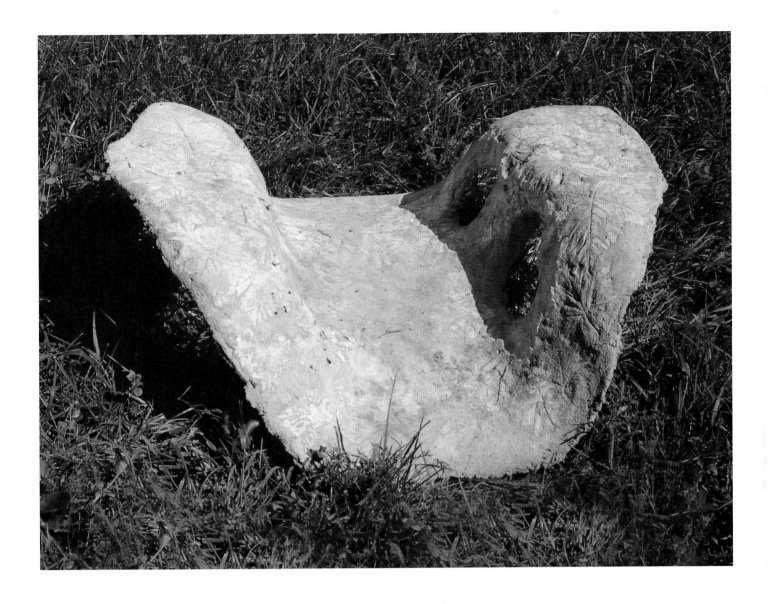

A Foot Bridge

Starting out with the idea of building a small footbridge, like one might use in a garden setting, Bo designed this small, rounded structure. It is interesting in that it incorporates a *faux bois* effect, a French term meaning *fake wood*, and was finished using dried leaves to create natural impressions on the handrails and top surface, and stained for added effect.

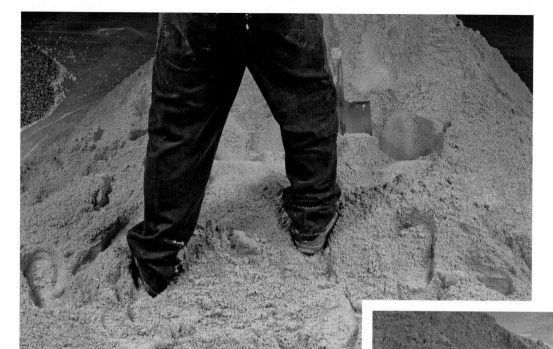

Using a shovel and his hands, Bo begins to move sand into the desired shape for the bridge, packing as he goes. Feet are very good tools for packing.

Adding water helps to bind the sand. Packing is critical. You don't want this sand to pull away from the concrete because that would weaken it.

The bridge takes shape. Pat it with the palm of your hand, hitting it firmly. You're also working to smooth out any imperfections you don't want showing in the final product. Finger impressions and palm prints, however, add to the organic feeling; and using your hands is part of the fun of working with concrete! Forming the mold is very much like playing in the sand and making sand castles.

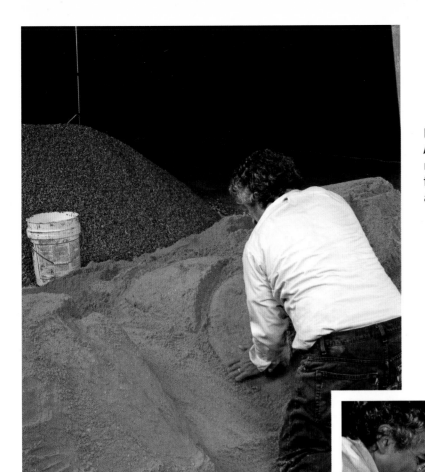

Bo incorporates "branches" for a *faux bois* effect. The goal is to create a sense of natural branches and vines intertwined to form the structure. Use your hands to pat and compact the mold as it is formed.

After the initial soaking with the hose, you will want to have a spray bottle handy. In the sun you would be spraying it with water a lot, because the sun and heat would be working against you. It all depends on how much moisture there is in the air. The goal is a very compact mold that doesn't crumble.

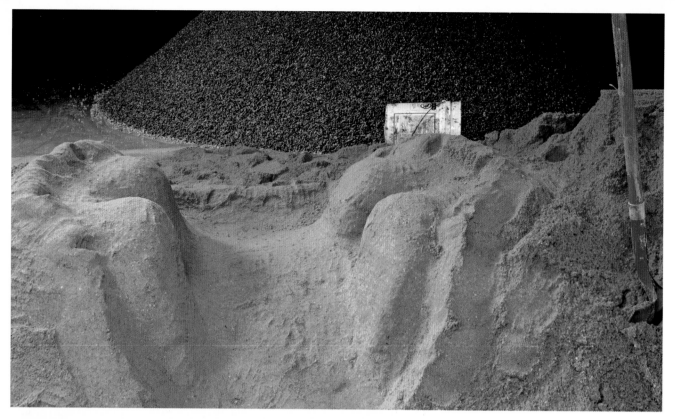

The mold is ready for the concrete application.

A spade was used to chop a bag of concrete open down the middle and allow a shovel access to the contents.

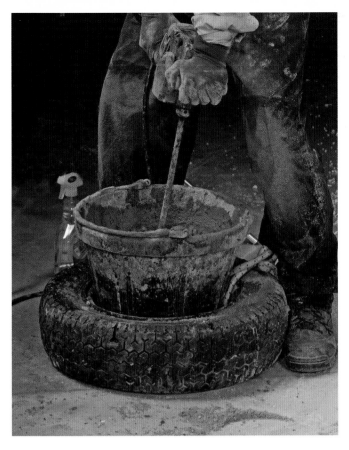

A hand-mixer, shovel, and a bucket are the only tools Bo uses to mix his concrete. Others prefer a hoe and wheel barrel. Bo likes to set his rubber bucket in an old tire to stabilize it. You can use any kind of bucket—they all work. A variety of hand tools can be used to mix the concrete, too, but plan on getting lots of exercise.

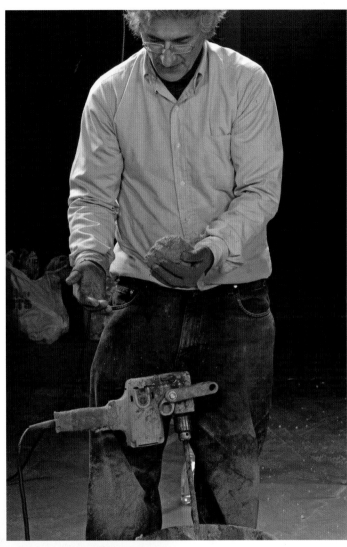

Be very careful to add only a little water at a time. It's very tempting to make it too wet. The goal is a snowball consistency. Pick it up (with latex gloves on) to test that it packs well.

Bo is using dry sycamore leaves, scooped up in the woods, to create a pleasing texture on some of the more exposed surfaces.

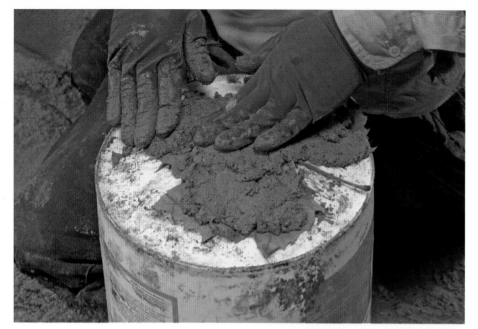

Set the leaf on a hard surface and carefully coat with the wet cement. Press gently to get the impression. It is preferable to remove the stems from your leaves, as the raised, exposed stems tend to weaken the structure a bit.

Set the leaf carefully into the mold. You can't, obviously, do this on a vertical slant. You have to have some tilt so that it won't fall.

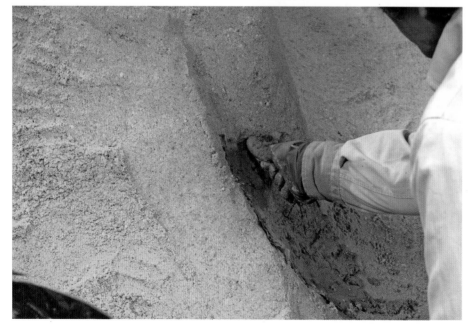

Again, it's very tempting for a person to make the concrete wetter, but that makes it slippery and harder to work with.

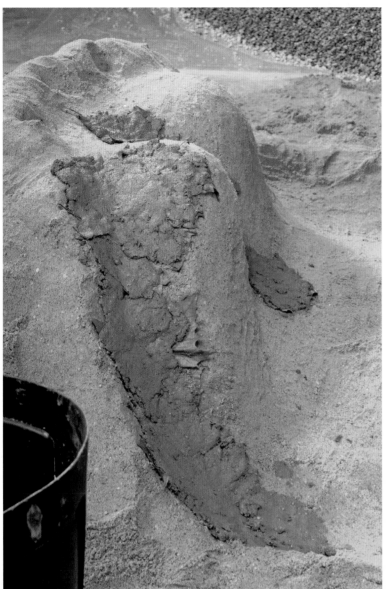

By working from the base up, the coated leaves form a base to anchor the leaves from slippage. Leaves can be broken to create smaller pieces. We don't want them to overlap. To bond them together, add more concrete and make sure that the material is integrated.

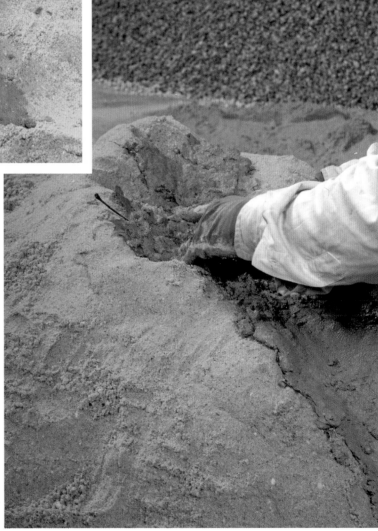

Concrete may also be applied to the leaves once they are in place on the sand mold. This eliminates the need to carry the concrete-covered leaves from one place to another. However, we are trying to avoid disturbing the mold, and the pre-application of the concrete allows more pressure to be applied, resulting in a better impression.

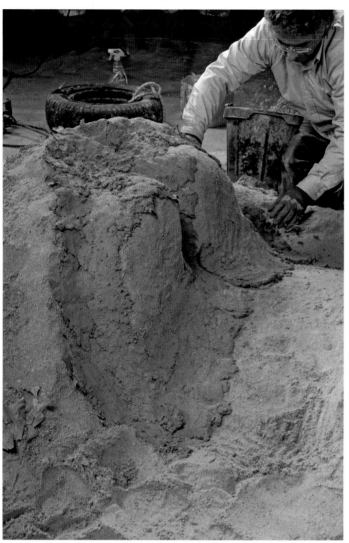 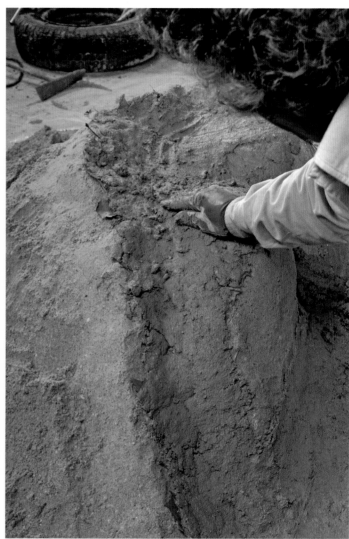

Concrete is applied to the base of the mold, without leaves. This concrete should have greater moisture content. The sand will instantly remove a lot of the excess water. The leaves absorb a little, but not much.

More concrete mix is applied over the leaves. Again, this concrete can be more moist.

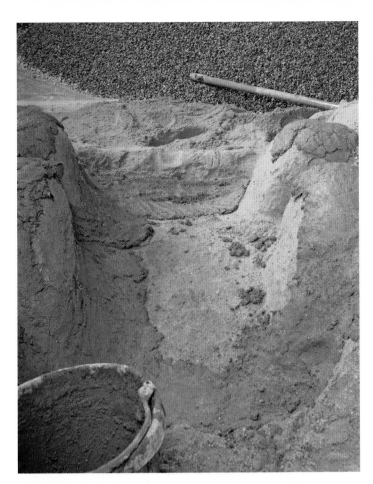

Moving up the opposite slope. Concrete alone is used in the center, and leaves and cement are used on the sides of the form. Fill in the base on the far side of the mold.

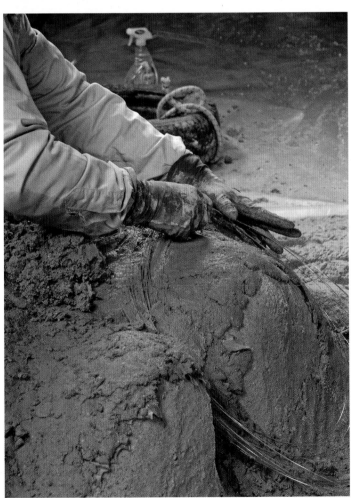

It is time to place the wire reinforcement. We start with our first coil.

Wet concrete (mortar mix) anchors the wire into place, integrating the two.

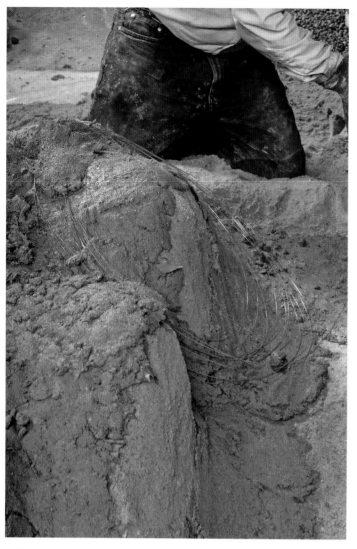

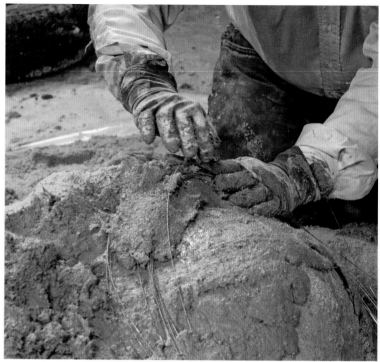

Pats of wet cement are set on top of the wire at critical points to anchor it in place. However, the entire wire is not covered so that we can see the course of the wires as we place adjacent layers and try to avoid overlap.

The wires are placed to give maximum coverage; the coils are carefully spread and arranged, not bunched up in one place.

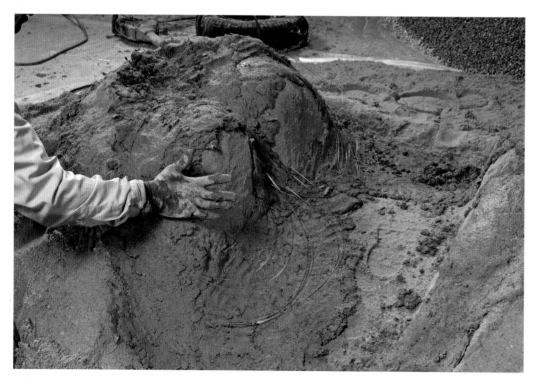

Another coil is fitted on the far side of the bridge. The two open holes represent planned holes in the raised sides of the bridge.

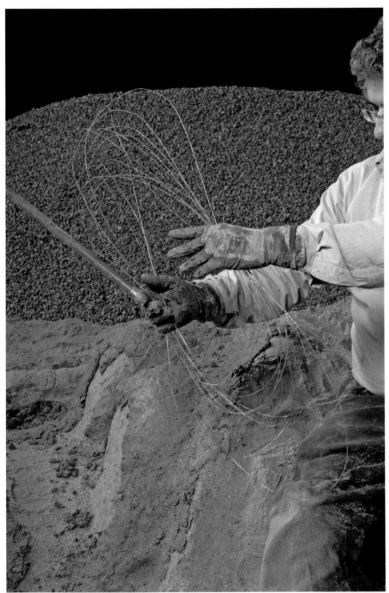

A coil can be bent into an elliptical form and used to create a span-like support.

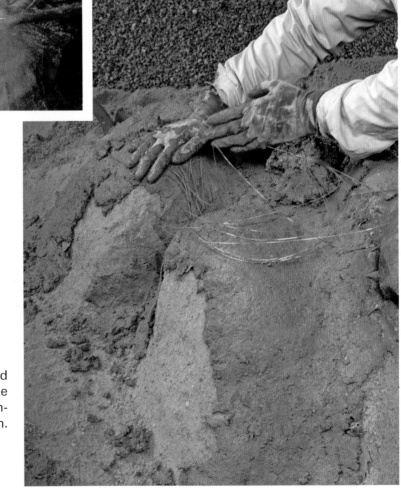

A coil is bent into an ellipse and placed along the top edge of the form. The coil is also bent to conform to a dip in the form.

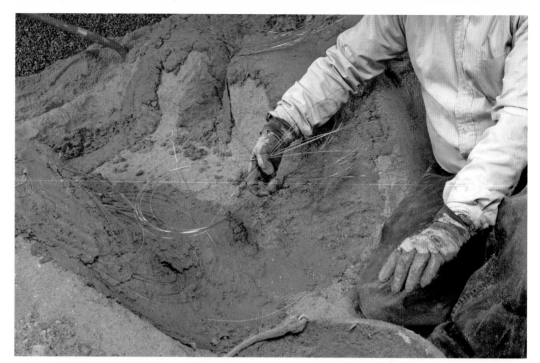

Squeeze two sides to create an ellipse and overlap with earlier wire.

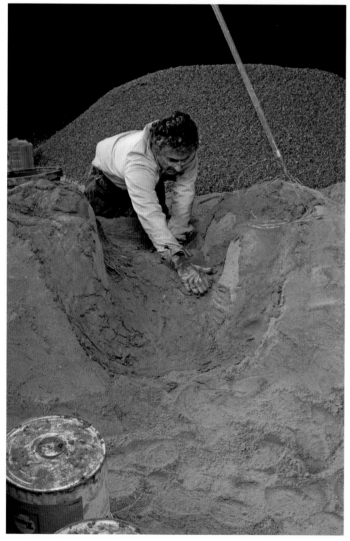

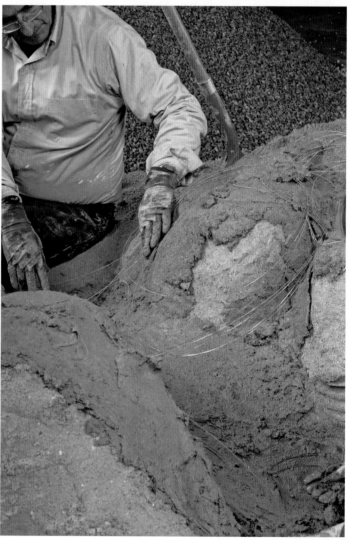

The goal with this bridge design is to leave these open spaces, creating a rail effect and minimizing the weight of the finished product. Bo will place about 20 coils all together.

Again, don't completely cover the wire at this stage so you can remind yourself how much wire you have applied.

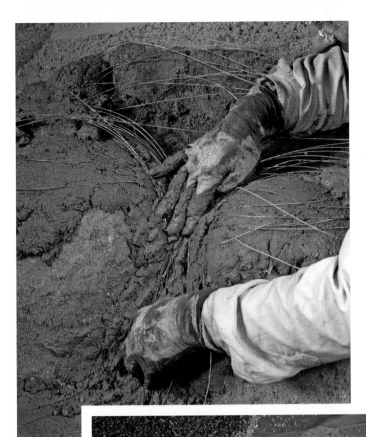

The wires need to be spread out in the gaps along the sides of the mold before the concrete is added to secure them.

Reinforcing wire is placed along the side of the bridge project.

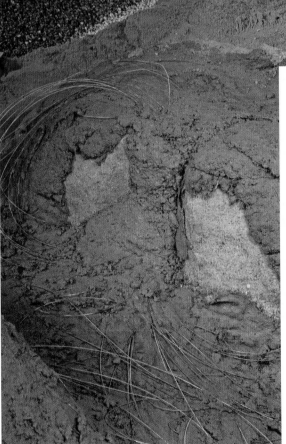

Applying more concrete over the wire.

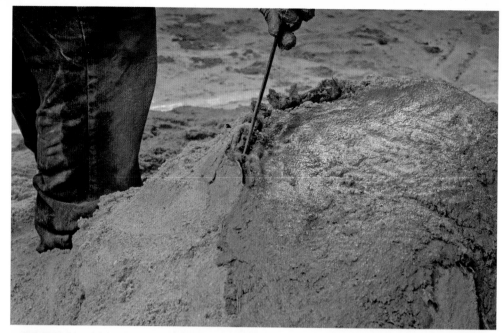

Cut away the rough edges of the leaves sticking out along the perimeter of the bridge, creating a straight edge.

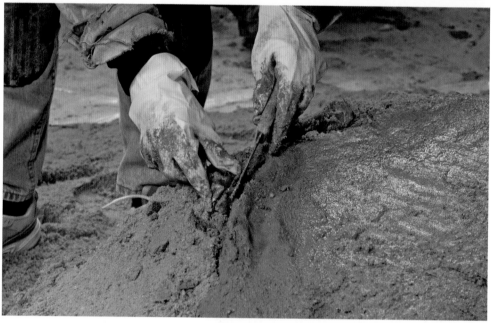

An old kitchen knife is perfect for this job.

As you clean up the rough outer edges, build up the sand again to support the bridge structure.

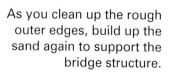
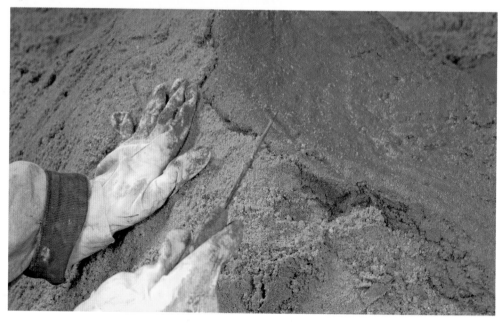

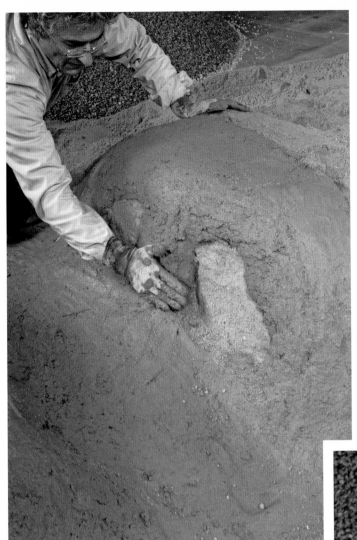

Apply additional concrete over the top to cover the wires. A green pigment was added to the cement mix for this final layer to give the bridge a little color. In this case, Bo uses Davis pigments.

For a nice finish, add leaves to the surface of the bridge once the pigmented concrete is in place. Place the leaves carefully to avoid exposing the supporting wire within or breaking off portions of the concrete structure itself. The leaves may either be patted into the surface and removed or left in place for added texture and color.

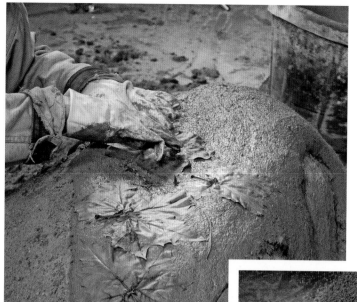

A big leaf covers a lot of territory!

The base of the bridge has been strengthened with additional pigmented concrete.

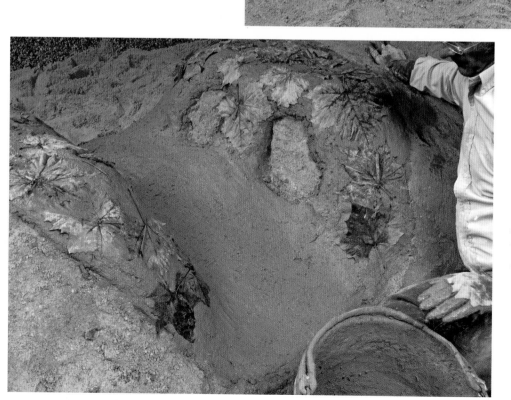

Leaves are added to the walkway on the bridge for texture, color, and interest. The leaves should be patted down well.

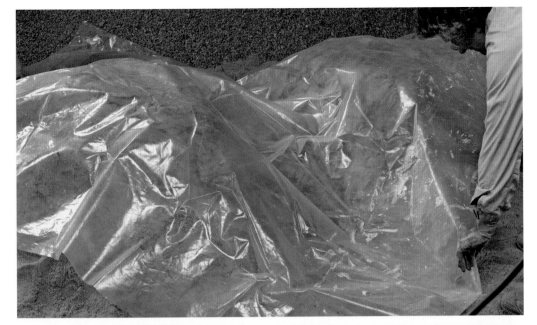

Cover the project with plastic sheeting to set. You may want to come back and mist the project over the course of the next couple hours, and then daily, in order to cool the cement and slow the curing.

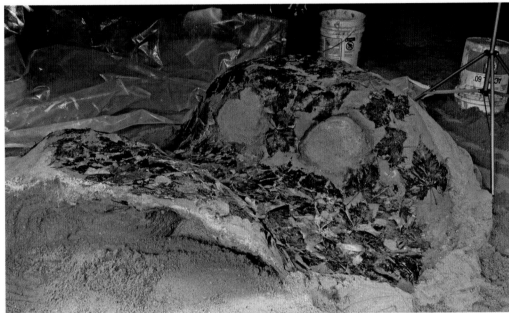

The next day we uncover our bridge to add another decorative touch. The leaves have hydrated and darkened in a chemical reaction to contact with the curing concrete.

An acid stain is applied to a sponge.

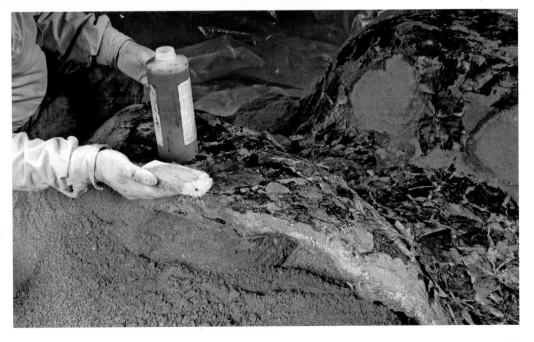

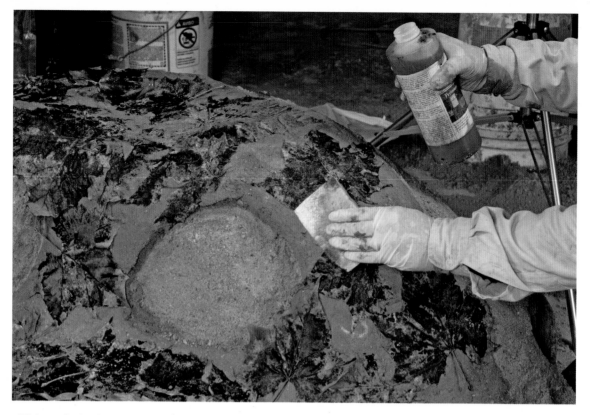

This stain is dabbed on to the partially-cured bridge. The stain will help highlight the outlines of the leaves.

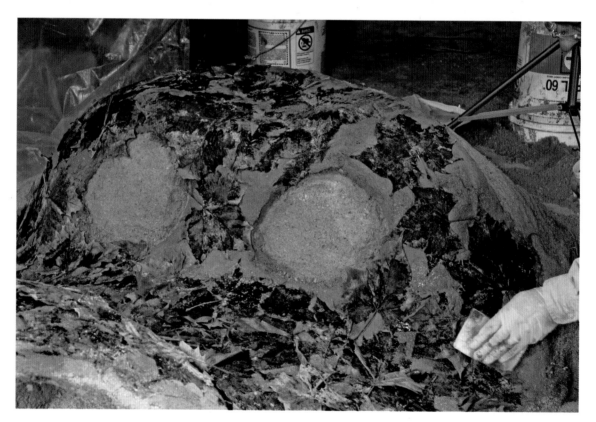

After curing, a power washer, a blowtorch, or a wire brush are options to help remove the leaves. Or they can simply be left to weather away.

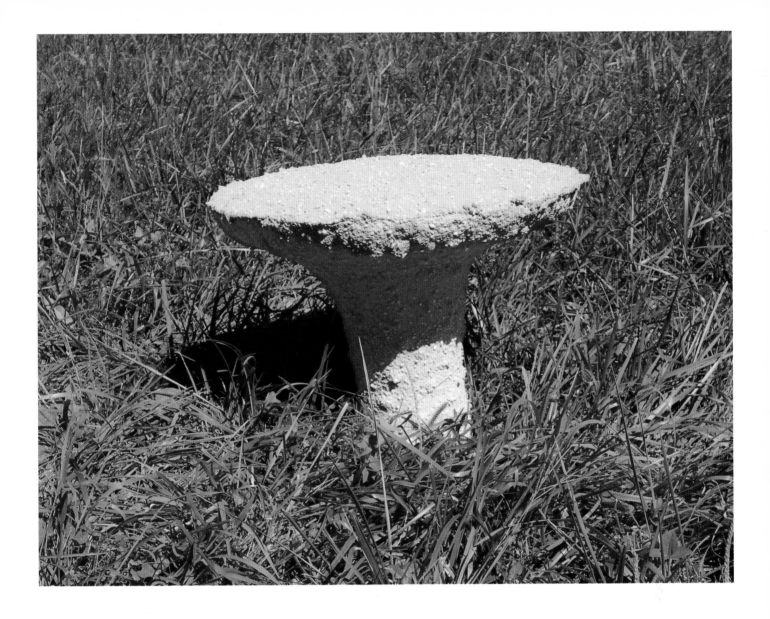

Toadstool

This is a delightful sculpture to make, and fun to find on a walk round the garden or in the woods. It is simply installed by digging a shallow hole and filling it with quick-set concrete mix, then embedding the base of the toadstool. That simple—you have a little stool ready to become an enchanted destination for children, or a thinking spot for you when you're seeking advise from the muse for your next project.

Bo used to enjoy healthy sales with sets of toadstool seats like these, each situated around similarly shaped tables, easily anchored into the ground.

Working in the sand, Bo creates a mold for the toadstool. Seventeen inches is a comfortable height for sitting, our goal in creating this toadstool seat. The hole for the stem is carefully compacted to make it firm.

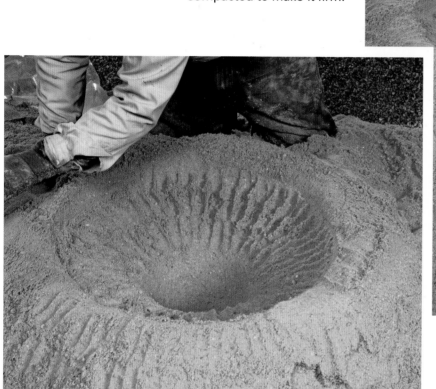

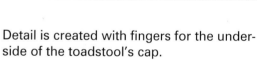

Detail is created with fingers for the underside of the toadstool's cap.

Bo mixes a small batch of very wet cement slurry the consistency of yogurt. This is pigmented red and poured into the grooves created for the underside of the mushroom cap.

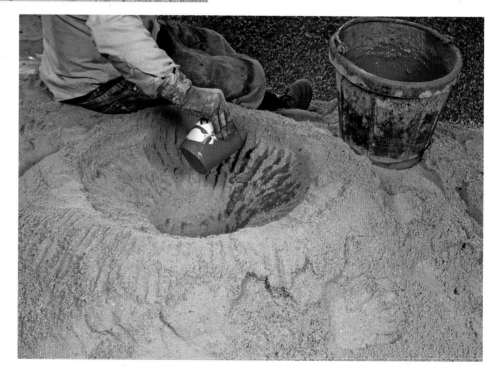

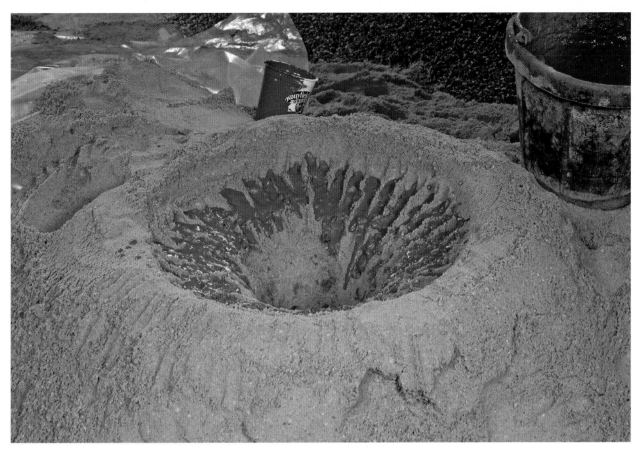

The slurry is poured carefully into the finger-marked impressions.

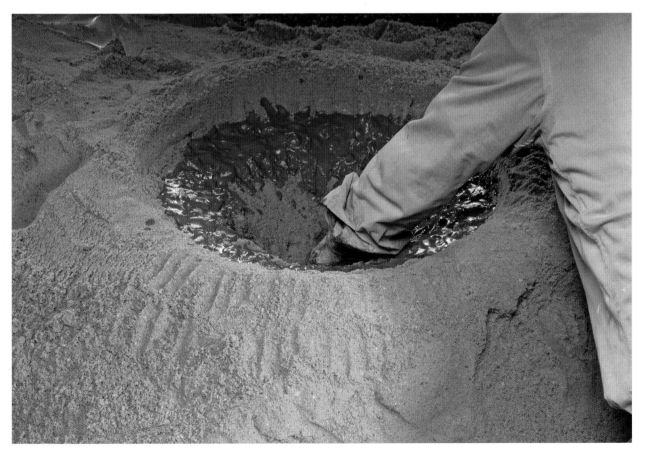

The slurry is in place.

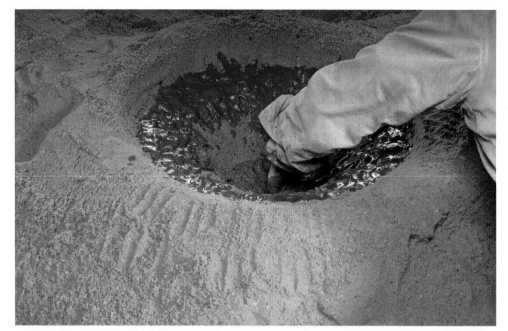

A heavy, drier layer of concrete is used as a base.

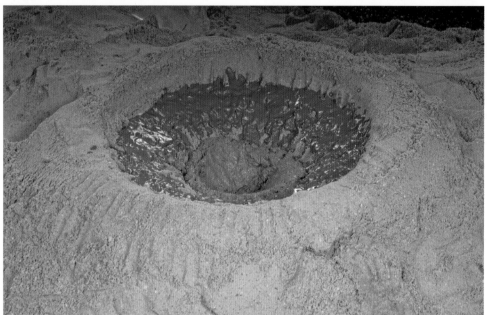

Bo builds the stem from the base up, forming the outer perimeters first. First coat the sides of the stem, leaving the center to fill in afterward.

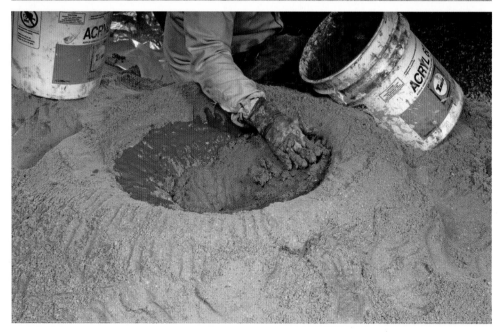

He carefully adds a heavier, drier layer of Ferro concrete mix as a base for the seating area without disturbing the decorative slurry. This is then gently patted down to interlock the two mixes.

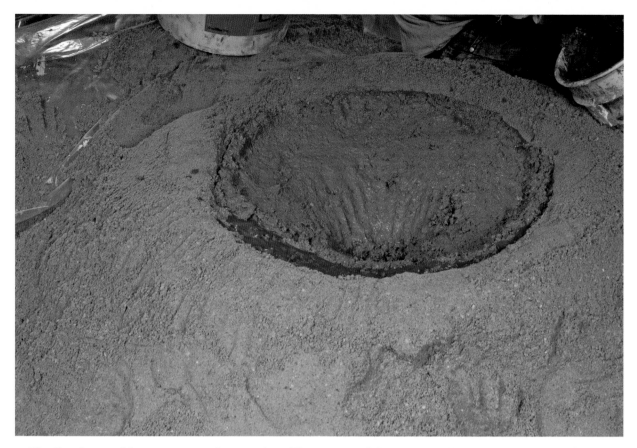

The first layer of heavy cement is complete. The center of the toadstool is built up using gradations, from slurry, to medium texture, to a heavier cement. Be sure to use your fingers to integrate the layers.

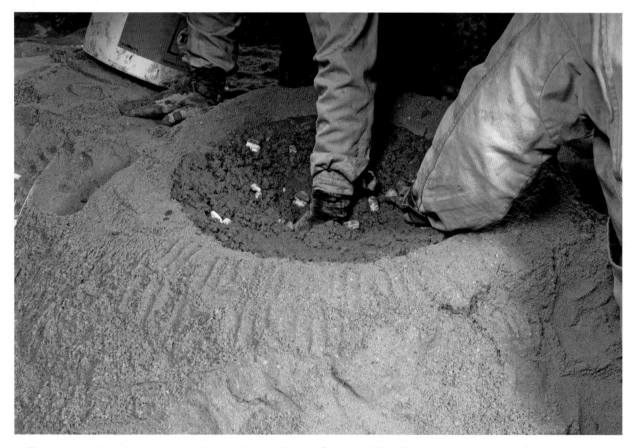

The stem of the toadstool is filled with the Heavy Cement Mix. Compact the center of the toadstool and push the driest mix down into the core for strength.

Foam peanuts are encapsulated within the cap of the toadstool to help minimize the weight of the finished sculpture. Make sure the peanuts are well encapsulated in the concrete.

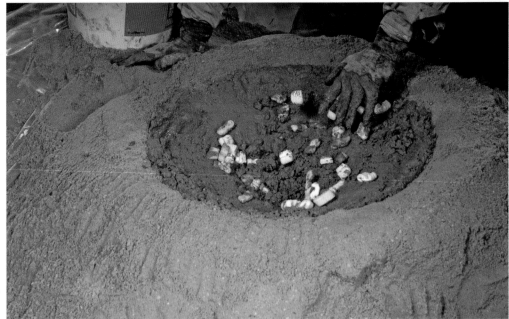

When concrete is stiff in your bucket, the best way to loosen it to get it out is to turn the bucket on its side, bang it, and remove the dry mix as it shifts to the bottom side. Repeat.

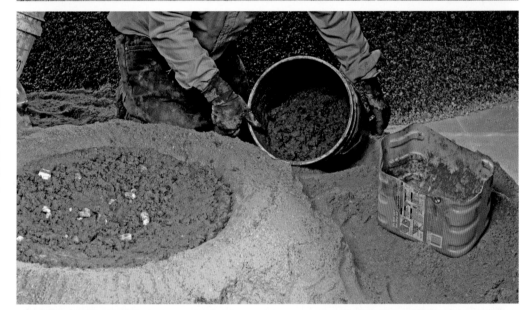

The slurry is given a dappled texture with the fingers, then covered with sand to help leach out the water on the concrete overnight.

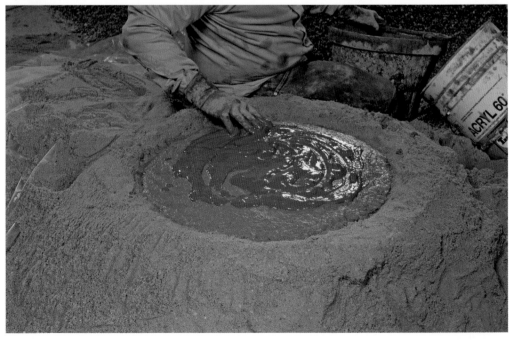

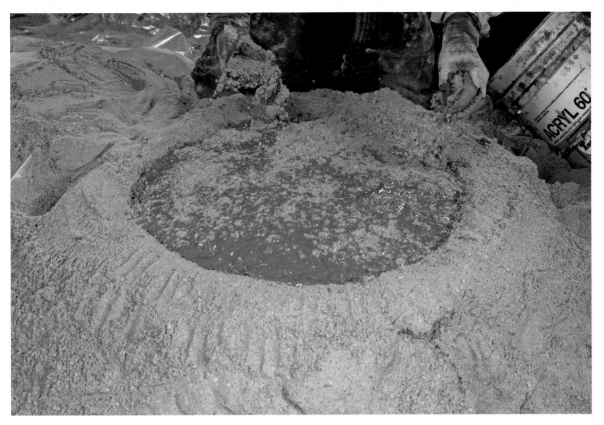

The raised dome of the toadstool seat is finished with the red slurry.

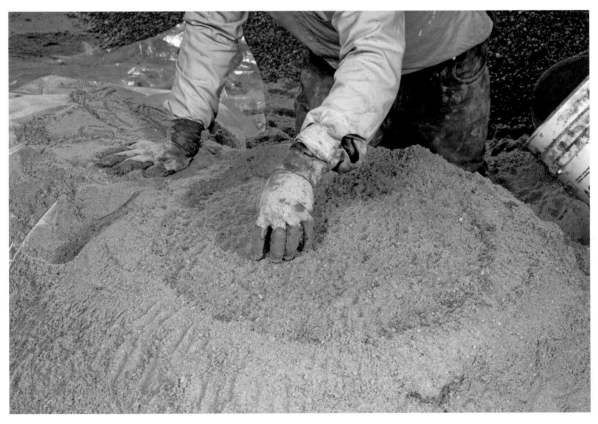

Bo pokes at the sand covering the dome for added texture.

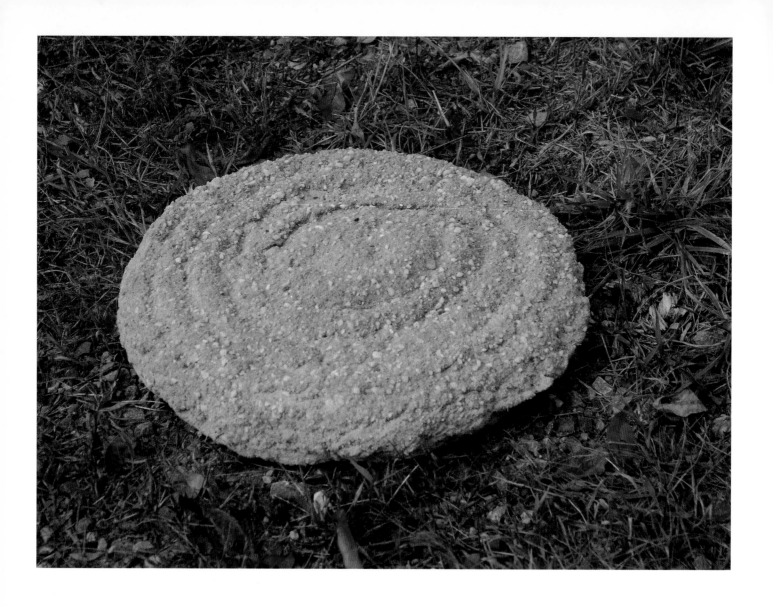

Stepping Stone

A super simple project is a stepping stone. A circular impression is created in the sand. Fingers can create impressions needed to achieve a swirled surface.

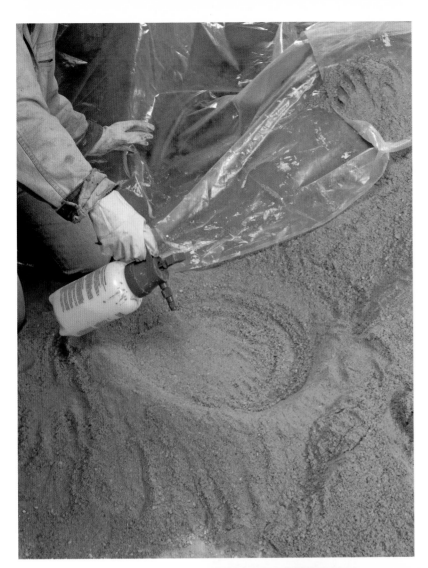

A pressure sprayer is used to wet and compact the surface.

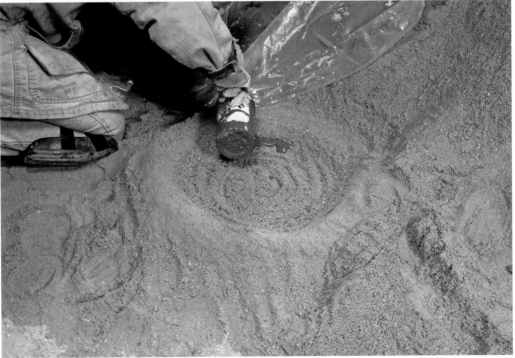

A cement mix the consistency of yogurt is mixed, using a red pigment.

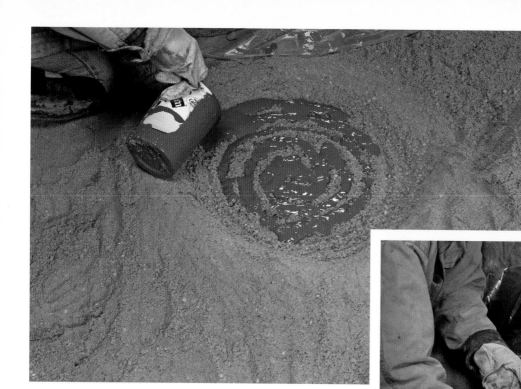

This colored mix is poured into the channels in the stepping stone.

Place the gravel-reinforced cement into the stepping stone mold a little bit at a time.

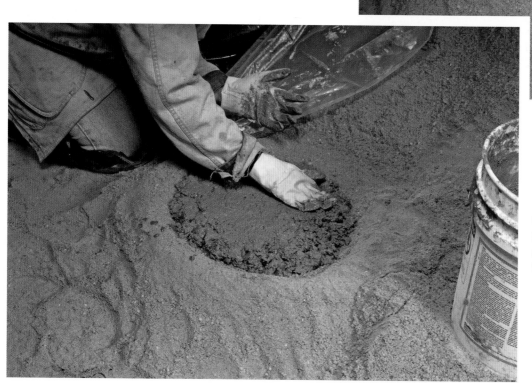

Once the surface of the mold is covered, tamp down the cement gently to integrate it.

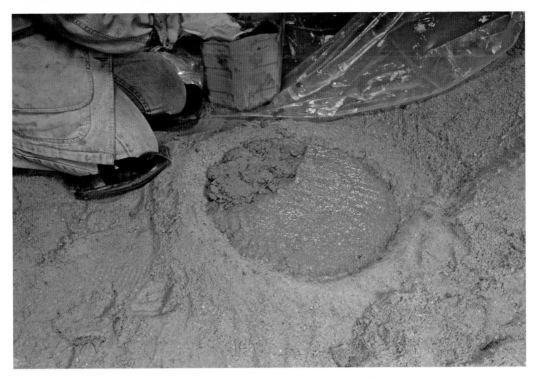

A second layer of heavy cement is applied.

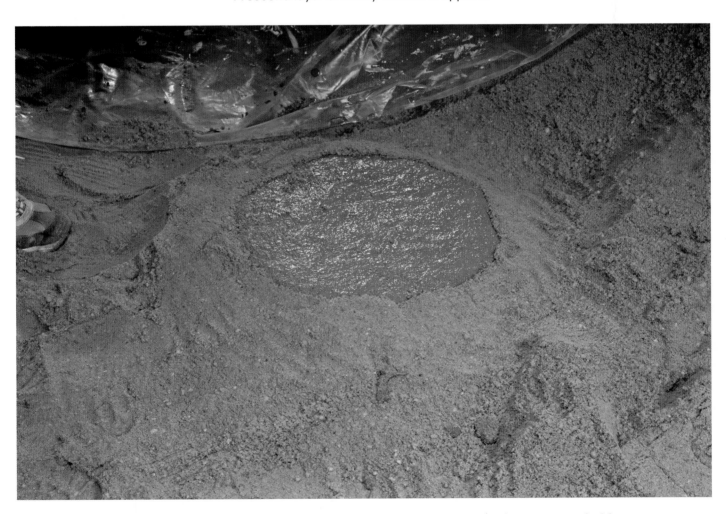

The stepping stone is complete. Make sure sand supports the edges of the stone as it dries.

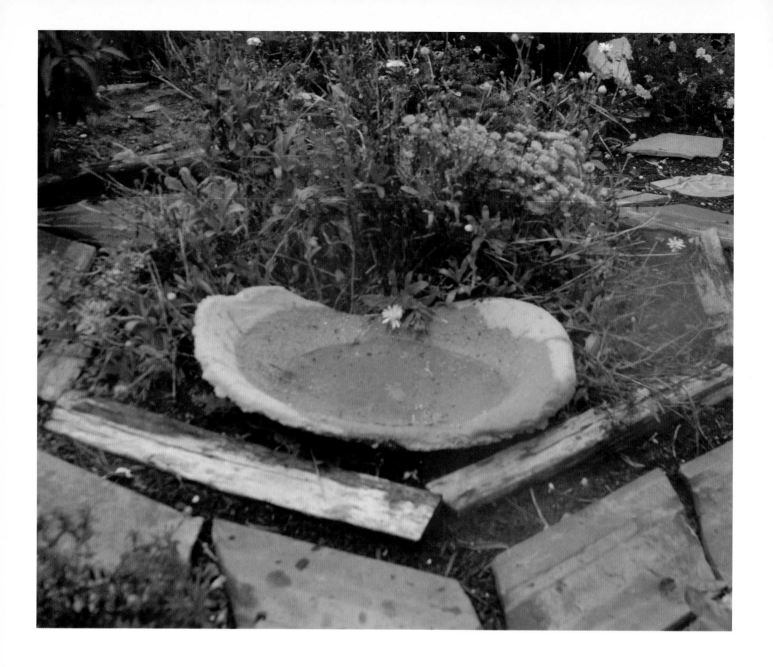

Birdbath

Here's a fun and simple form that can take on any shape your imagination dictates. Bo builds a simple, oval shape. He used to build these in production mode. Making one, covering it with sand, and using that as the base to build another right on top. Stacked up, each one forms a mold for the one on top. They can be built inverted, or upside down.

You can try lots of variations on this simple outdoor water receptacle. Use a large rhubarb or elephant ear leaf to create a beautiful impression in your bowl. Or create an image, or a word, or the handprint of a grandchild, to forever adorn your garden ornament.

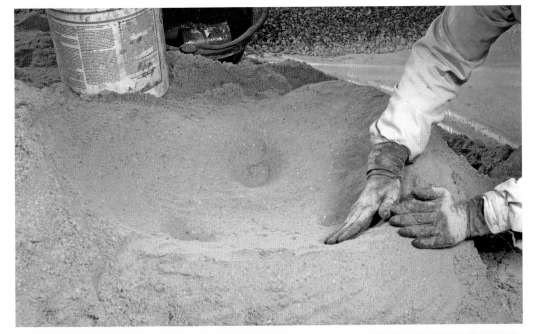

A basin form mold is created, the impression complete with wavy edges. Three deeper impressions will serve as feet to keep the bath from rocking.

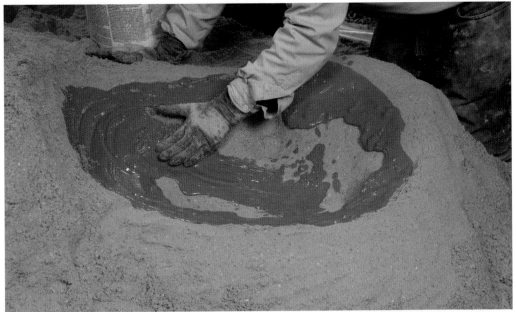

A slurry is added as a first coat.

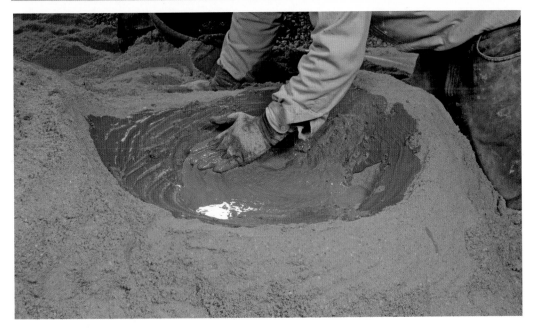

Another slurry, sans the pigment, is added to fill the feet.

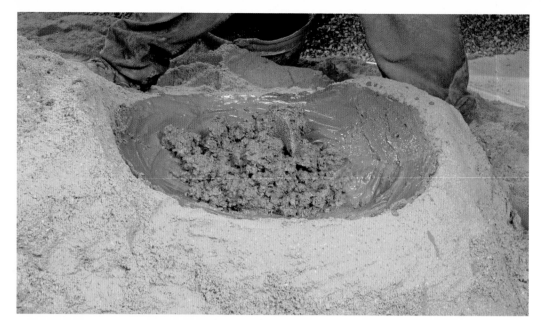

Gravel reinforced concrete is added, using a batch that fills approximately 1/3 of a bucket.

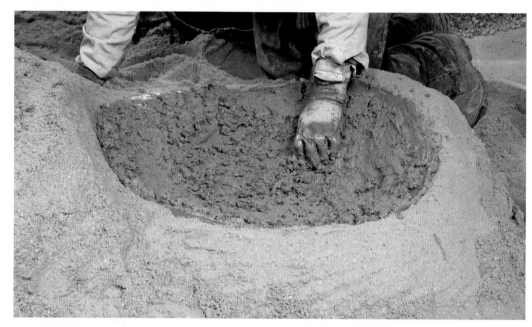

The super dry mix is spread about a half inch thick. A wetter mix will be added on top.

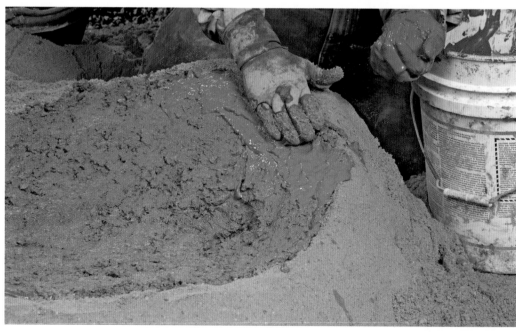

A slurry is added on top and the edges are massaged.

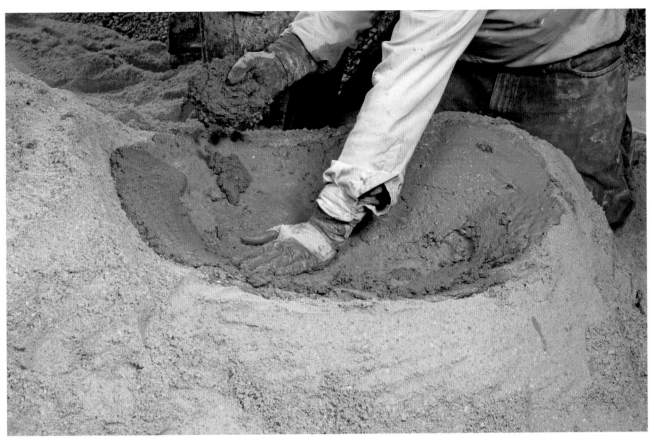

A semi-thick layer of pigmented mix is added, sandwiching the dry, gravel-reinforced layer.

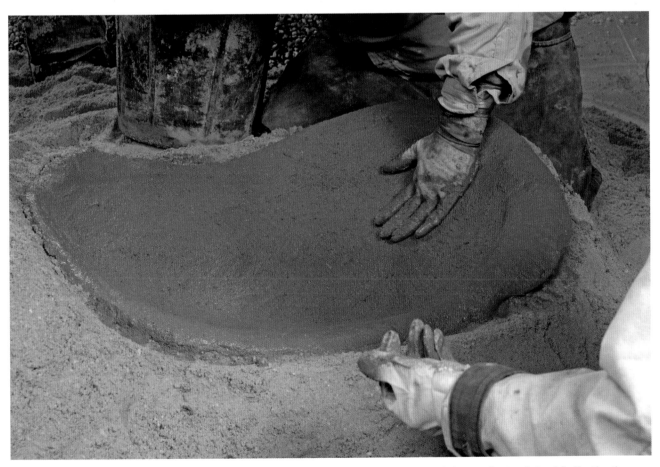

The rest of the job is hand sculpting. The red slurry is smoothed around the surface of the birdbath, the edges shaped and formed. The birdbath will then be embedded in sand to cure.

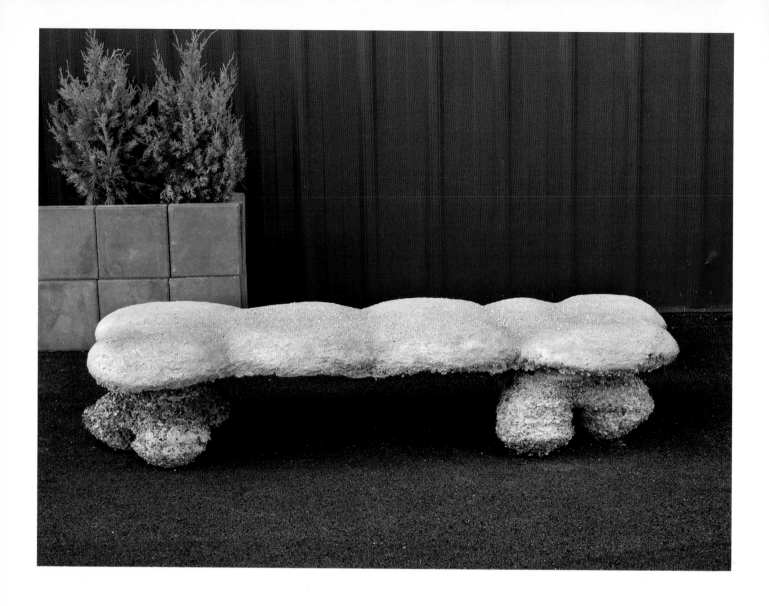

Bench

This wonderful, wavy, organic bench seems part and parcel of a rustic landscape. The ball-feet are richly encrusted in gravel, as is the underside of the bench, giving it the feel of something that formed itself from the earth. Simple to make, it's a very substantial project and one that is sure to draw praise from friends and family, as well as providing a place to accept all the accolades at your leisure.

This bench could be a bridge, as well. The supports could as easily be placed in the water to help support a span. The concrete should stand up to life in water for many, many years, though a flood event could certainly shift its position.

Bo prepares the mold directly into limestone gravel, incorporating some sand to help stabilize the form. Because the gravel is more likely to move, this project will use a very stiff concrete mix, which we will refer to as Extra Rich Mix.

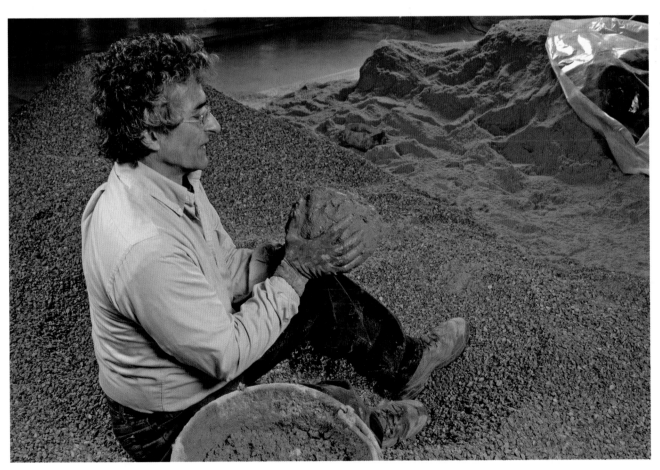

Bo is going to sculpt nodule-type feet by creating big balls from the rich concrete mix. When finished, there will be five big balls per bench leg—three on the ground for stability, creating a tripod effect.

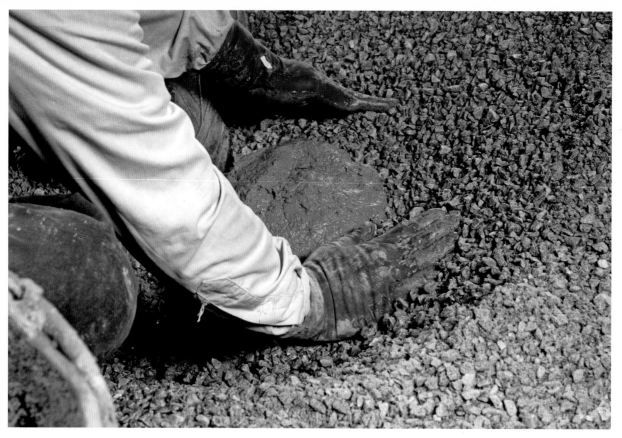

Here, gravel is part of the mix, the "aggregate" in the concrete. Gravel is also used to support the sculpture. Be sure to use sand-free gravel and be careful not to incorporate the gravel into the mix. It is support, and also surface decoration, but pushing it into the mix would weaken the final product.

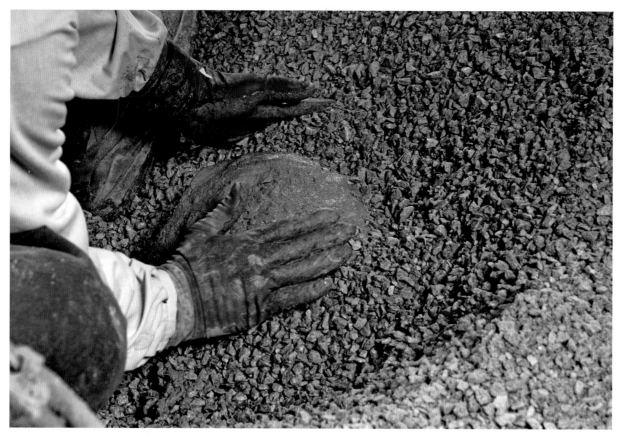

Continue to build gravel up around the first ball until only the top remains. This design idea is for an organic look. We aren't attempting to make the forms perfect.

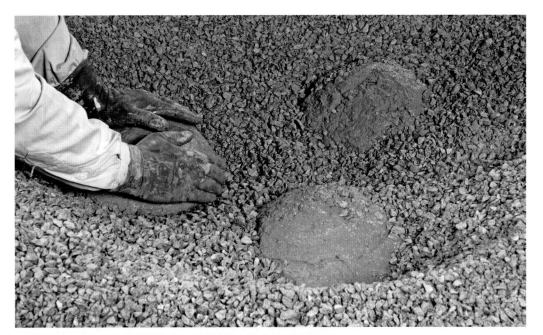

Two additional balls of mix are added to complete the tripod.

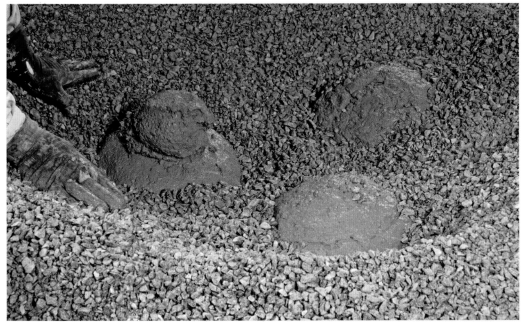

Knit or knead new material into the bases of the columns to incorporate additional cement, and reinforce the rising columns with fresh gravel.

Bo builds a base atop the ball feet.

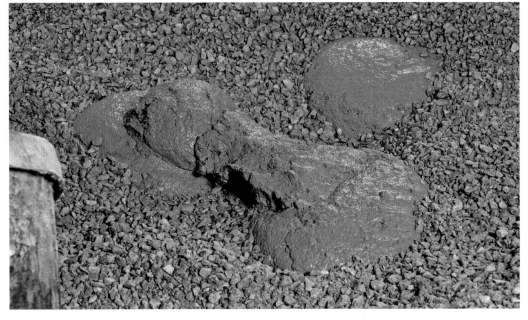

Three bridges unite the three-point base. Pushing on the surrounding gravel is another way to help shape it.

The walls are built up around the base in order to support the next layer.

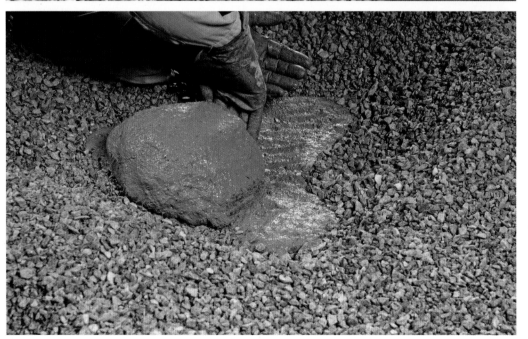

The first ball of the second layer is knit to the central base. The top of one leg on the tripod is rounded and then reinforced with gravel.

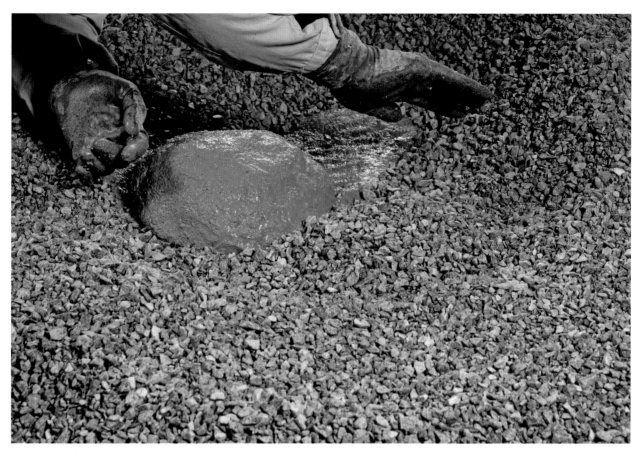

The second layer ball is shaped and …

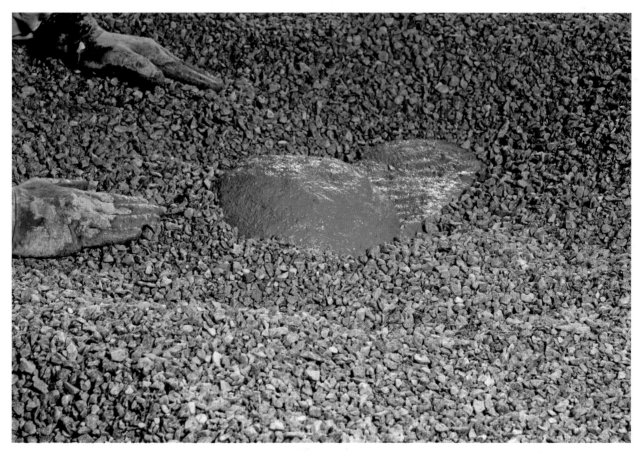

… reinforced with gravel. A rough outline shows how we will form the bench surface. The next step is excavating for the other support leg and then building it repeating the same steps.

Bo roughs out an outline for the entire bench in the gravel and creates the mold for the second set of legs, then repeats the steps outlined above to create the other base.

The feet on the opposite side are in place, the supporting *Y* between the feet is created and gravel is packed in around the structure for support. Using your feet is a fine method for compacting the gravel surrounding the concrete structure.

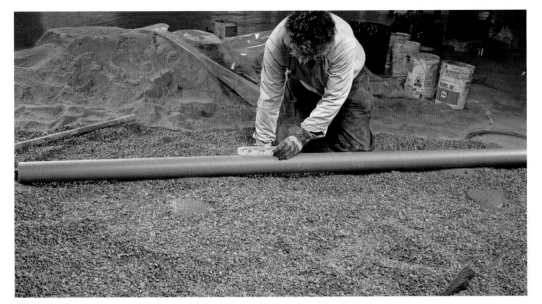

Look at the legs closely to make sure they are both of the same height. If not, adjust accordingly before forming the seat so that the seat will be level. Here's an easy way to extend your level's reach using a long object to check your work from end to end. The surface is prepared for the bench. We want an undulating, twisty bench.

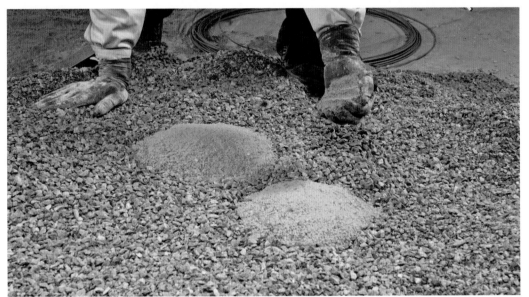

Sand is applied to the top of the legs as a "parting agent," to ensure separation of the bench and legs.

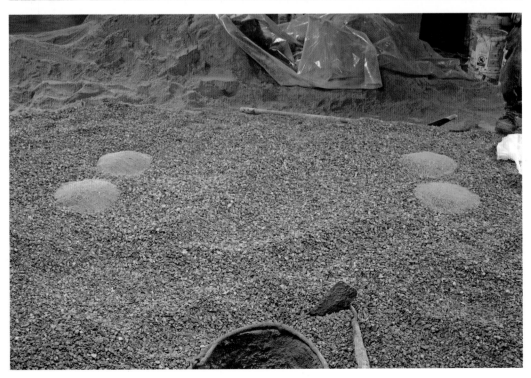

Bo is now ready to form the bench.

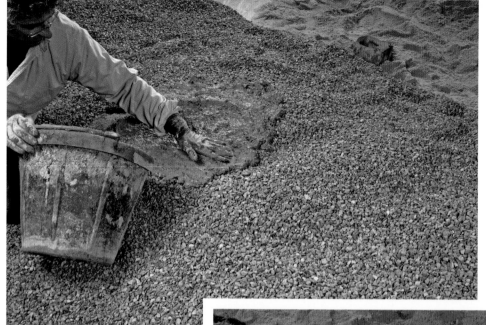

Use a flow-able Grout Mix to create a thin layer for the underside of the bench.

The concrete surface shows off the undulations in Bo's design.

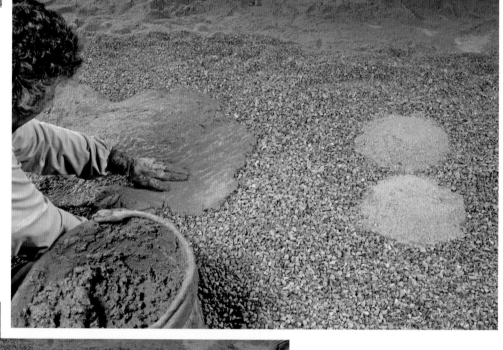

Set new additions of concrete on the previously laid concrete and then spread it to ensure that the materials are integrated.

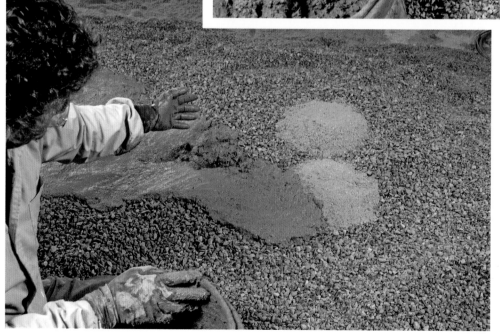

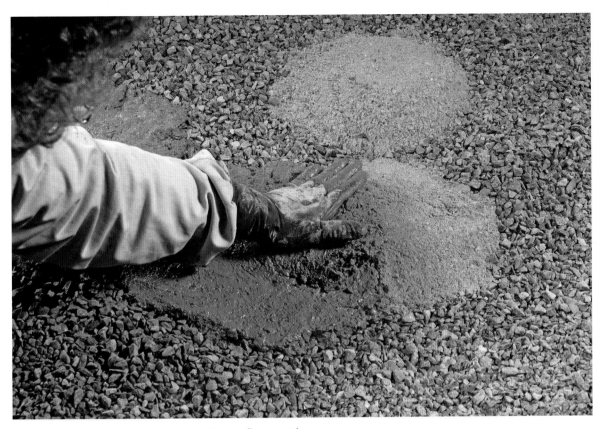

The pushing should be gentle, then a firm patting.

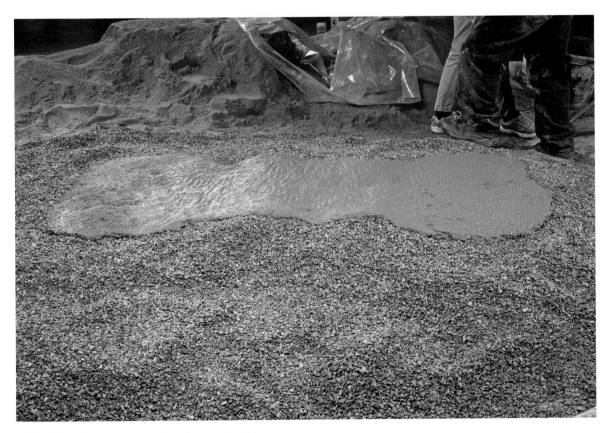

The first layer is completed over the legs.

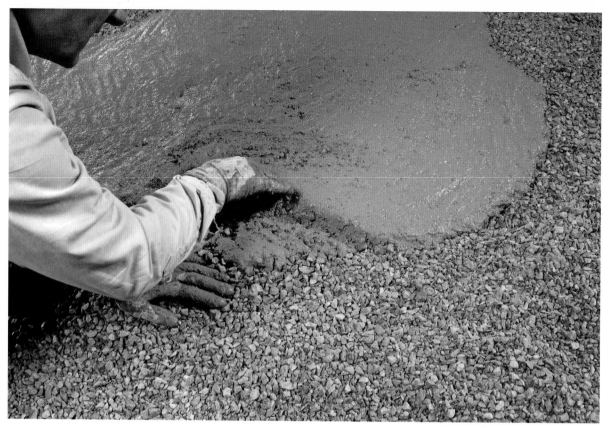

Feel free to dig out unwanted material along the bench edges to get the shape you want.

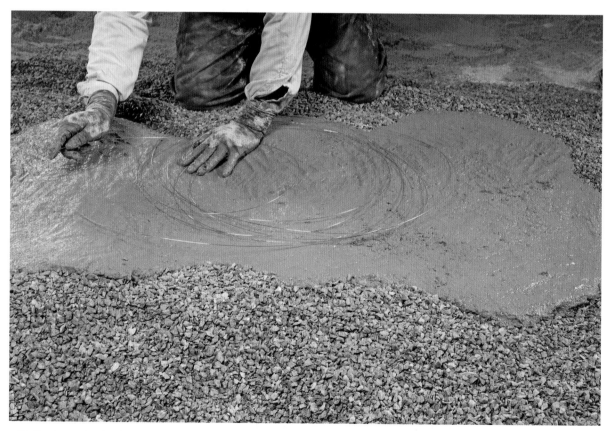

Coiled steel wire is added to the bench seat. The flat spiral coils overlap each other, and once the cement binds them together, you have a strong, chain mail-like mesh. The overlap of the wires increases the strength.

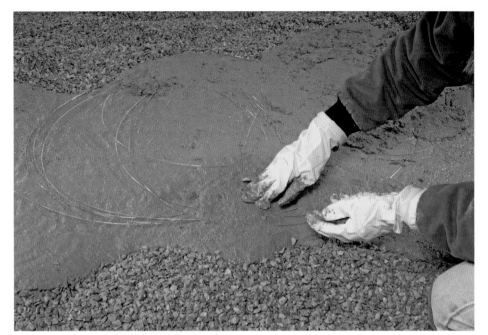

The wires are strategically anchored so that they are still revealed, and subsequent reinforcement can be put down without duplicating effort.

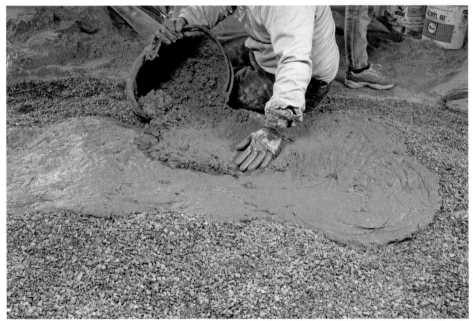

A drier layer of Heavy Cement Mix is added above the coil-laced cement. Another layer of coil will be applied next.

Bo seeks out dry gravel from the mound to help keep his mix dry.

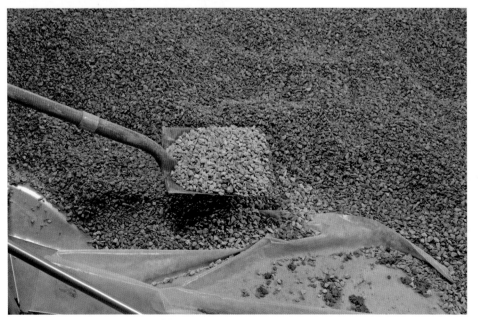

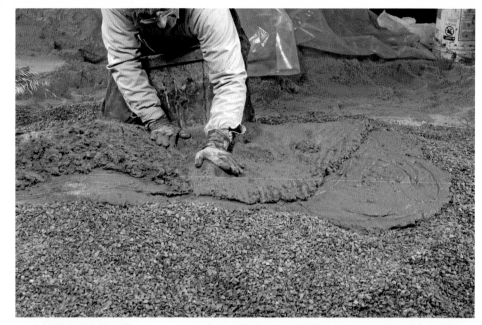

Another layer of concrete is added.

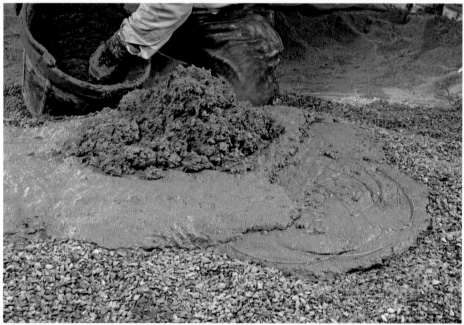

Note that you can add a bucketful in one spot and spread it out from there. Make sure to pat and integrate as you go.

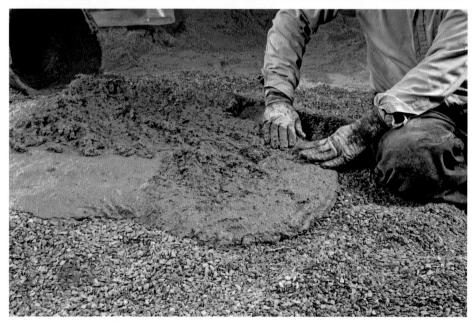

The edges are carefully rounded and shaped.

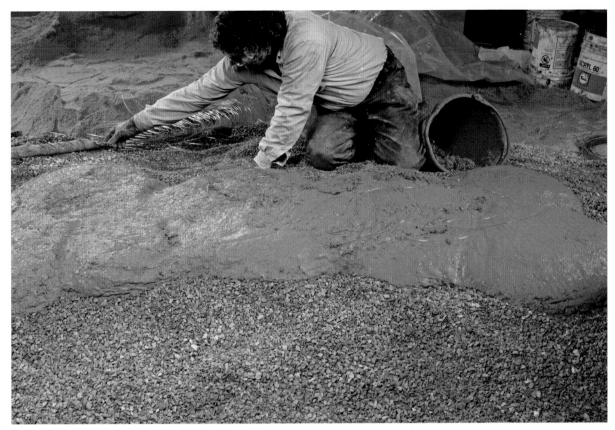

The top layer is added over the steel rings. The steel rings allow the structure to expand and contract a bit without cracking. The fiber added also is an excellent combatant against the tiny cracks that form with shrinkage. For a smoother surface finish, less sand and stone could be used; however, this increases the problems associated with shrinkage.

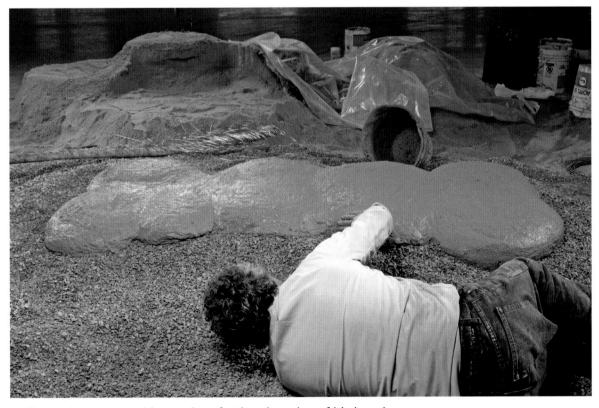

Bo works on smoothing and perfecting the edge of his bench.

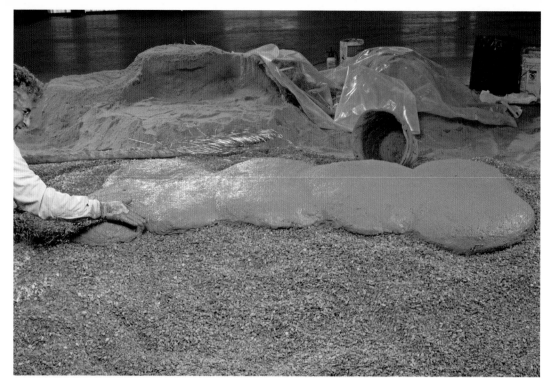

The finishing touches and creation of the final texture is the most fun stage. The entire structure is wet and cohesive, and behaves like an enormous, gelatinous mass as you pat it into shape, and stroke it into what will be its final form.

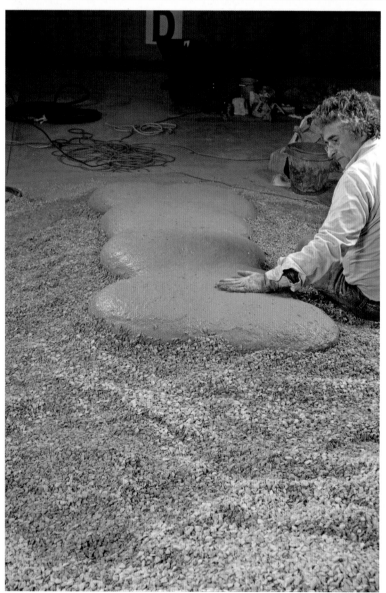

The concrete is allowed to set for an hour or two before returning for a final smoothing.

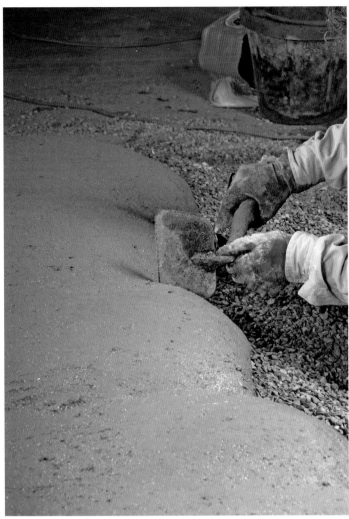

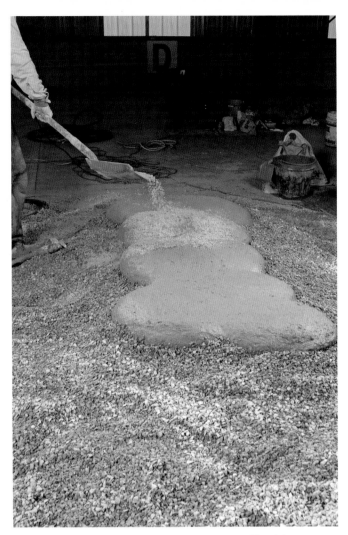

Any wires sticking out should be pushed in with a sharp, metal implement, and the concrete fixed around them again. Bo uses the head of an old hoe. This implement is also useful for pushing sand and gravel around while sitting in a sand pile. Think about the favorite children's tools for playing in the sand—you'll want to have similar toys for your endeavors!

The bridge is packed in sand, which will add texture and help with the cure.

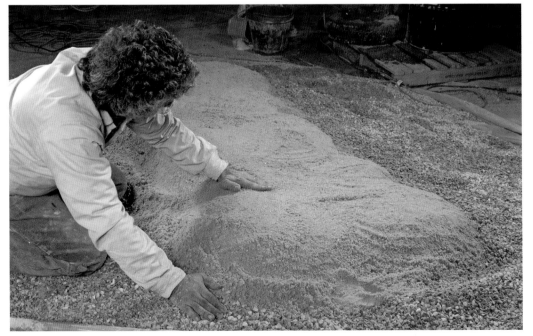

Bo gently applies a finishing touch to his sculpture through the medium of sand.

61

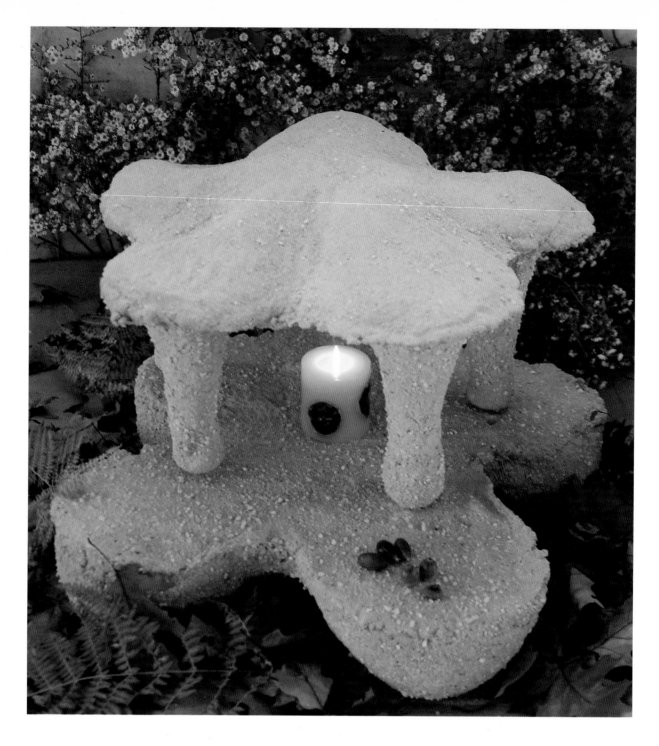

Fairy Lantern

Filled with candles on a moonlit eave, this would be an enchanting addition to a woodland path. The form finds its way straight out of Nature, and the process is an exercise in fun. The legs are carefully poked and compacted in the sand mound using a broom or shovel handle, and the surfaces are carefully groomed with water and whisk to create an ornament any woodland creature would feel at home with.

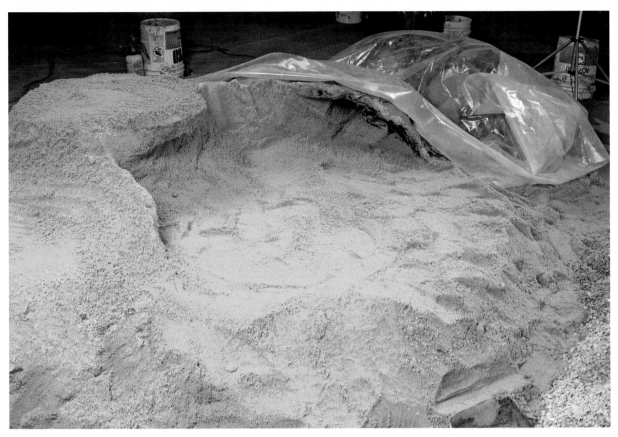

A plateau area is created and compacted in the sand pile.

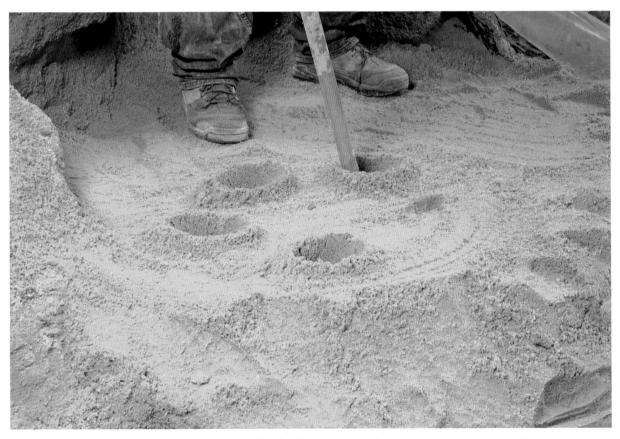

Use a shovel handle to create leg holes for the lantern legs. Remember, you are working to create a compact hole, firm and not too big. This is harder than it looks!

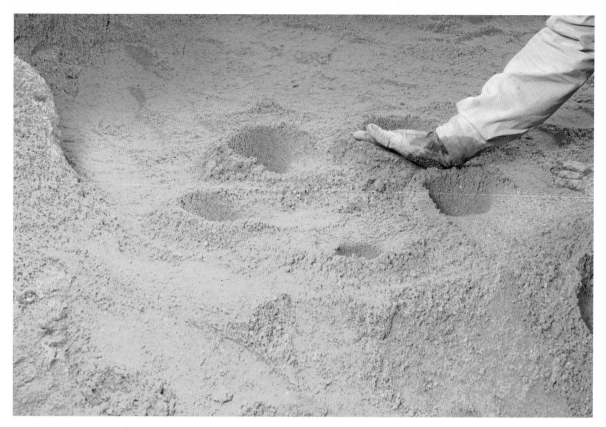

Loose sand atop the holes is carefully pulled away and compacted.

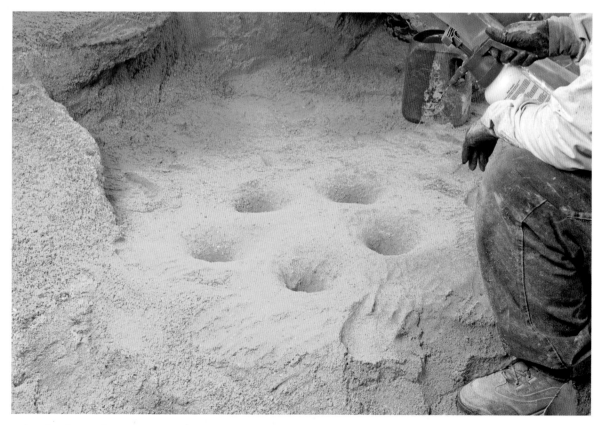

A raised area is created in the center using the loose sand removed from the holes.

In advance of filling the legs, a straight-stream sprayer is used to create a natural, pocked effect by exposing the stone in the sand. Here is the initial effect after spraying around the lantern legs.

Here's how it looks after the entire area has been sprayed. The larger aggregates in the sand are exposed. You can get a similar effect by dribbling water. Or try different settings on the garden hose. The sand mold takes on a very different appearance with the smaller particles washed away.

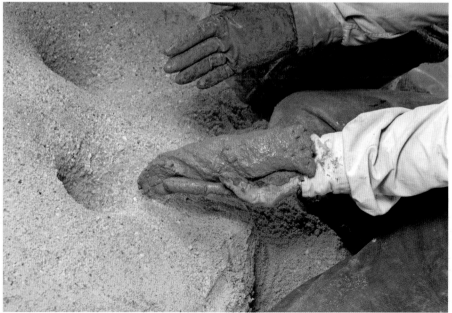

Prepare Wet Mix and make a salami shape to fill the hole.

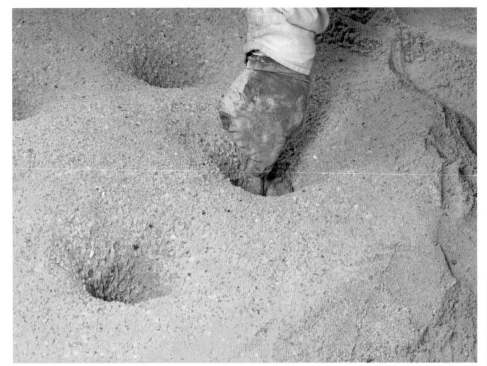

Poke the salami to the bottom of the hole.

Insert a smooth stick into the salami and use it to press the concrete in, making sure that concrete hits the sand all around and to work out any air. Bo uses a screwdriver handle. You want a smooth stick because the cement may try to stick to your tool and come back out. It is important to twist and work the stick out gently without disturbing the sand mold. Insert another salami into the hole left by the screw-driver and repeat.

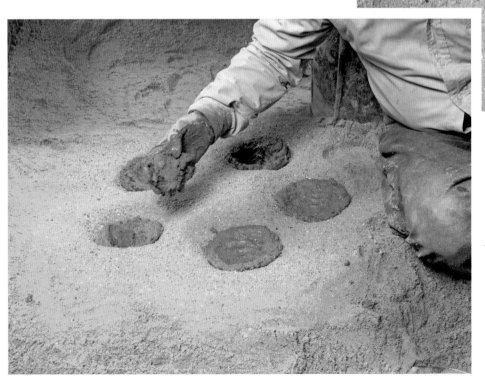

Continue the process until all five legs are filled.

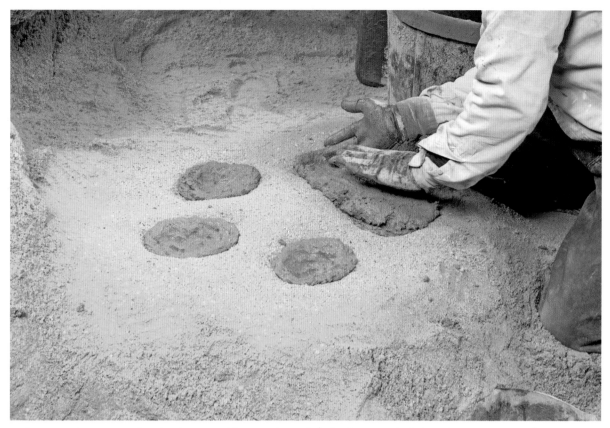

Create a layer to unite the legs and form a base for the lantern, knitting the new material into the old.

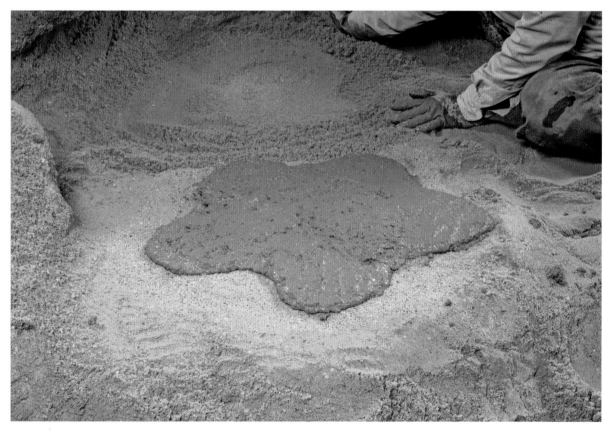

The first layer of the lantern roof is complete.

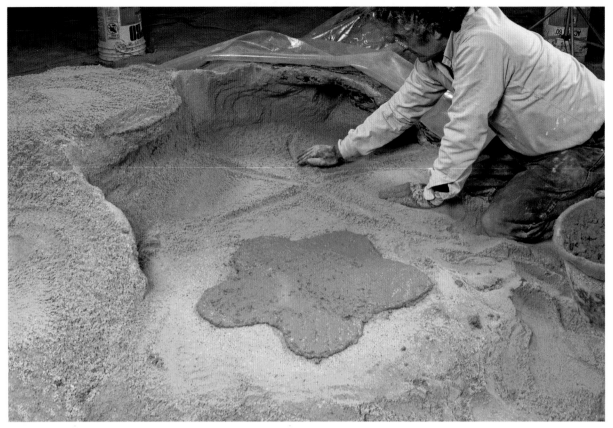

Create a new area in which to create the base.

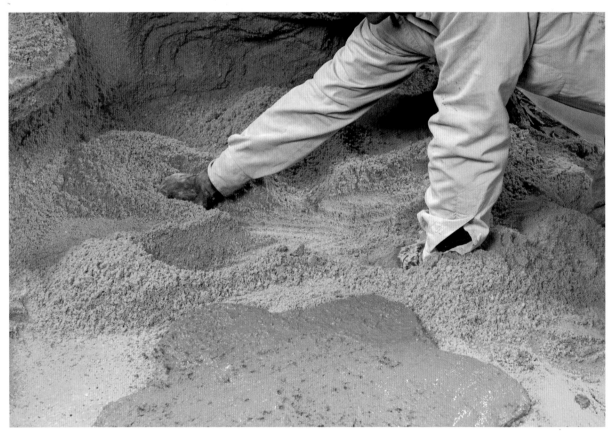

A mold is created, replicating the flower-like shape of the lantern.

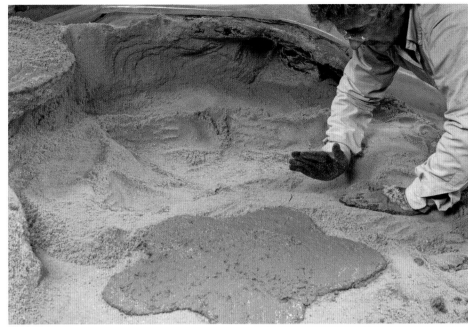

Compact the base and edges of the new mold.

Use a wheel or rounded object to compact the corners of the star base. Rounded corners are stronger than pointed corners.

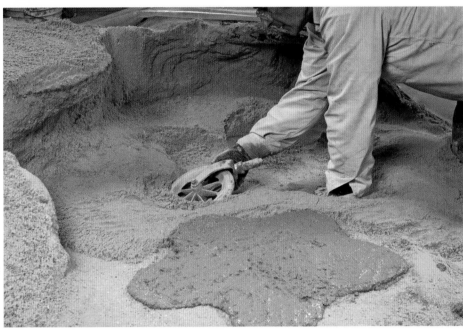

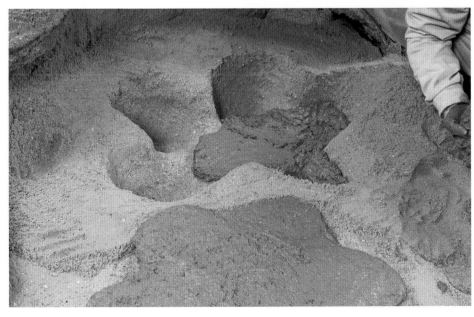

The first layer of concrete is added.

Concrete is pushed down into
the ball-like corner legs.

The entire bottom of the
form is filled.

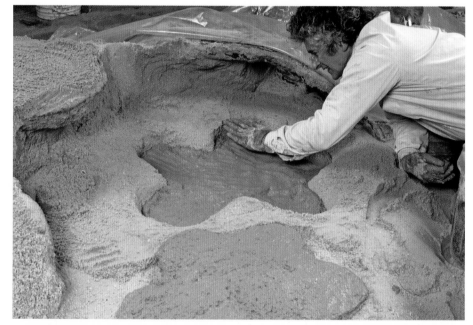

Elliptical wires are incorporated
into the star base.

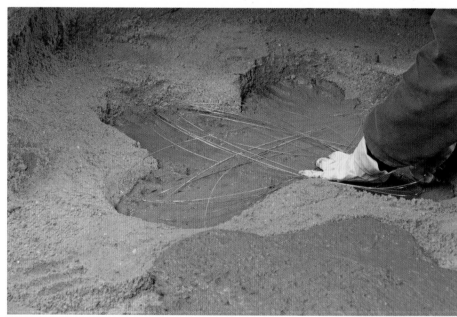

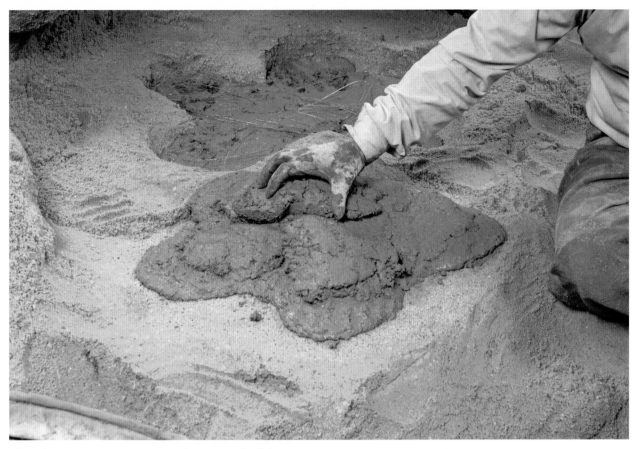

Bo places more cement on the cap to build a crown.

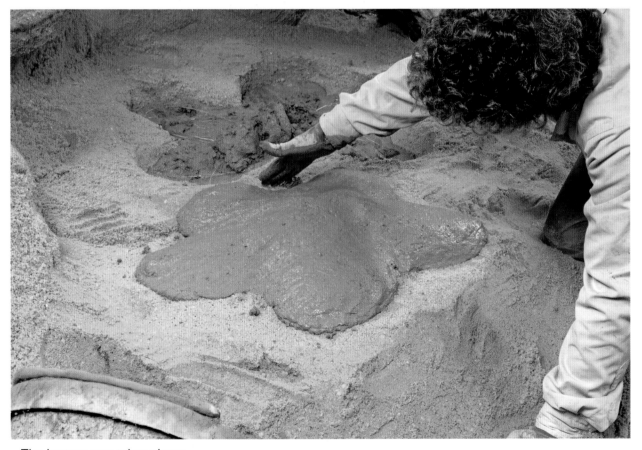

The lantern cap takes shape.

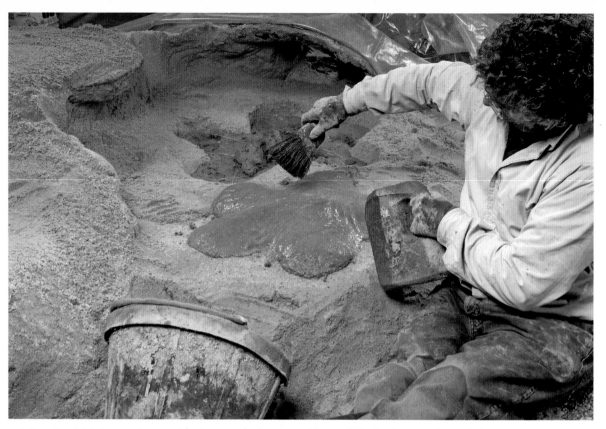

A hand whisk is used to spritz the top with water. This will help the sand to stick.

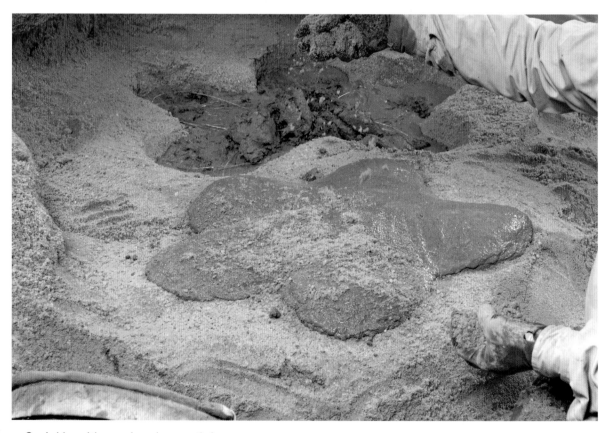

Sprinkle with sand and smooth in.

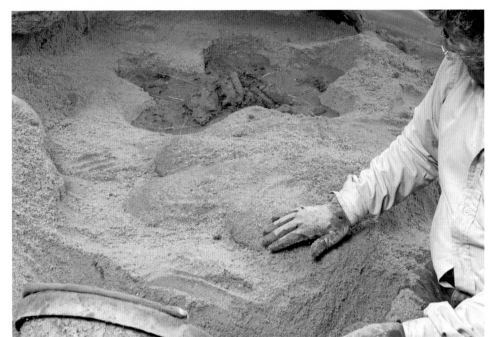

Pile on more sand and leave covered to cure.

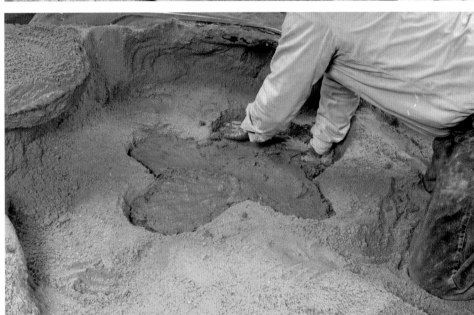

Back at the base, Bo fills the mold up with dry mix.

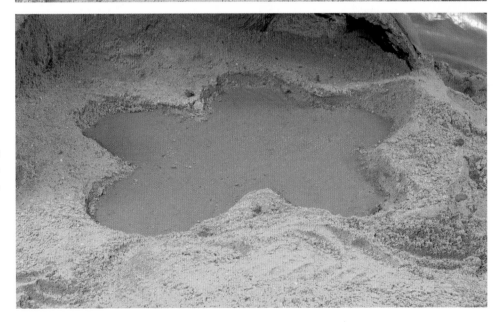

A final wet coat completes the base. Smooth and finish the edges.

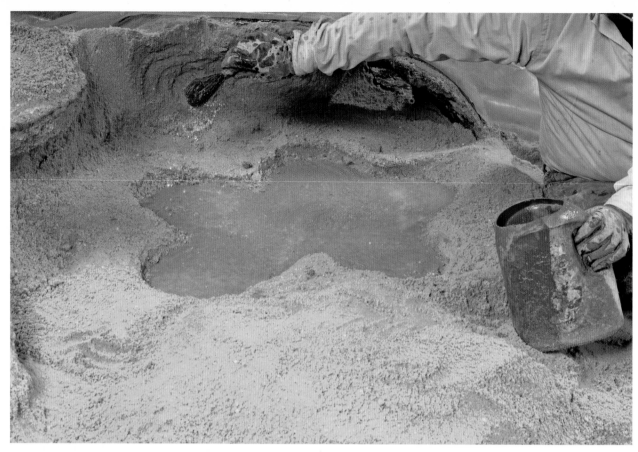

A sprinkling of water acts as a bonding agent to incorporate some sand on the base.

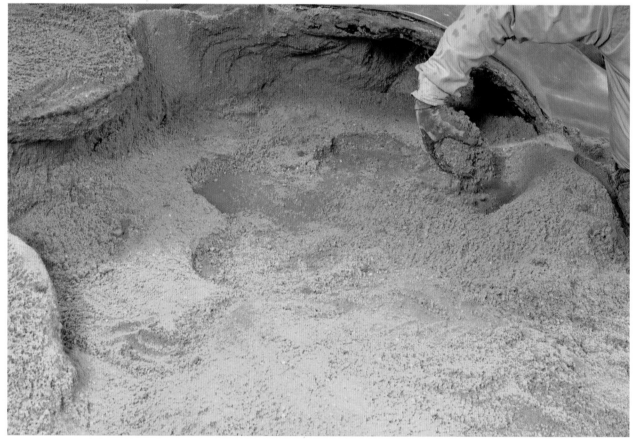

Cover with sand and allow to cure!

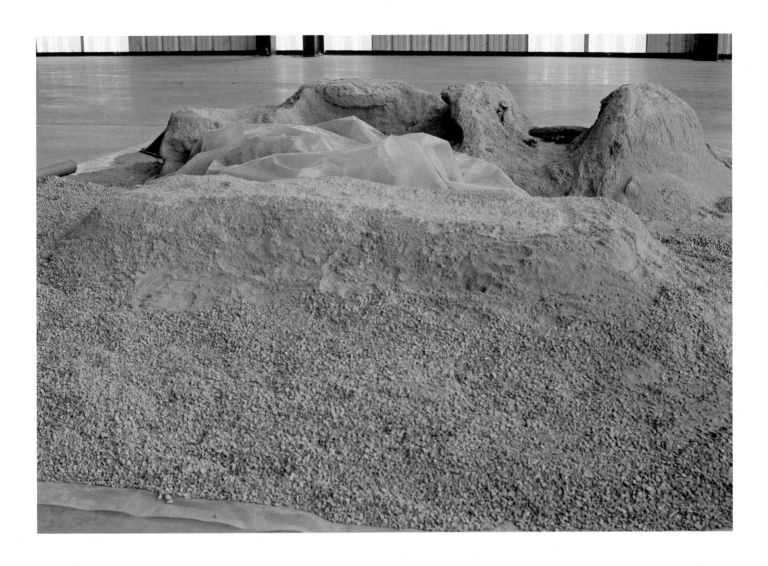

The Reveal

After weeks curing in a chilly warehouse, buried in gravel, sand, and plastic sheeting, our sculptures were carefully revealed using shovel, broom, and gloved hands.

As the sand was pulled from the buried forms, the pieces started to emerge. This is the top of the bridge.

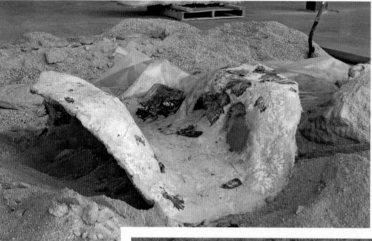

Most of the dried leaves came away with the sand as the bridge was brushed clean.

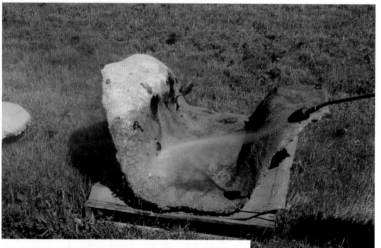

Power washing reveals the beautiful colors and textures on the bridge.

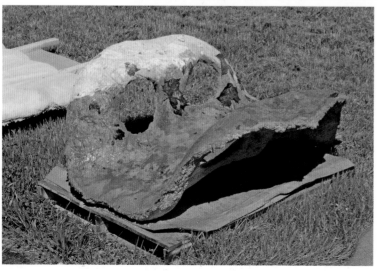

The footbridge cleaned up to be an interesting sculpture. The leaves created an effect that was very woodsy.

The bench is exposed via careful excavation.

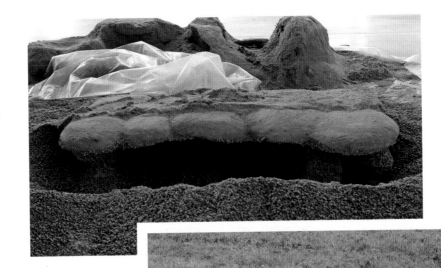

The bench seat and legs are cleaned off.

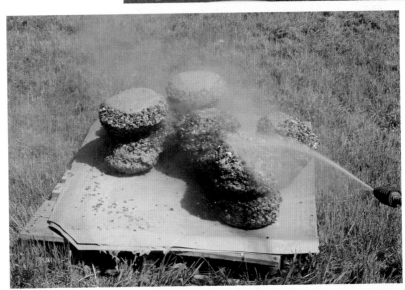

The legs to the bench were cast in stone. The final effect is very rough and gutsy.

The garden bench was over 4 feet long.

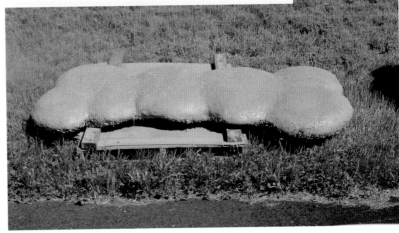

The cap of the fairy lamp and the base are revealed …

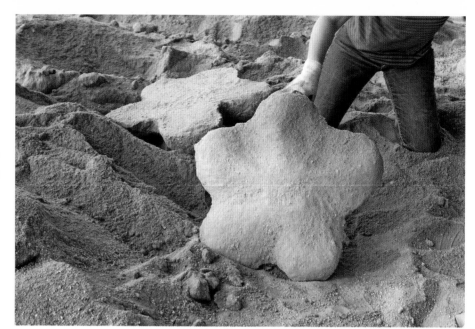

… and assembled for the first time.

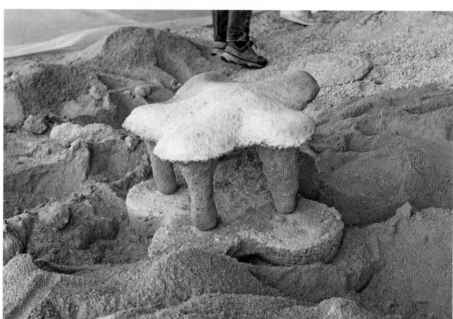

When the Fairy Lantern was revealed, you could just see it in the garden at night gleaming with candlelight.

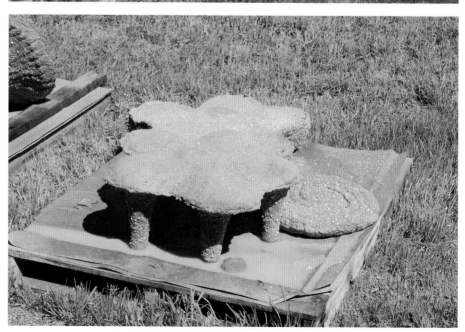

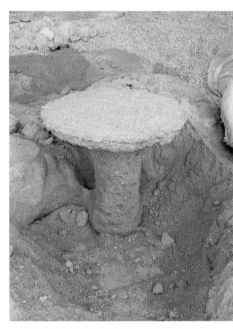

The toadstool, a whimsical garden ornament, was next to be unearthed.

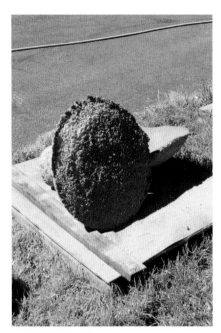

The toadtstool emerges, encrusted with sand.

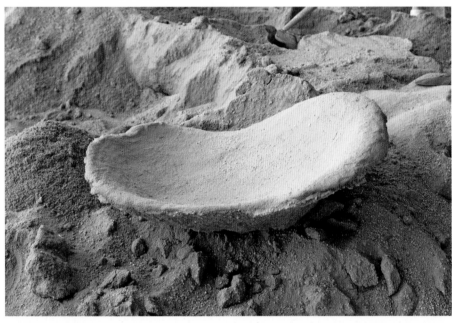

The birdbath came out easily looking ready for the birds.

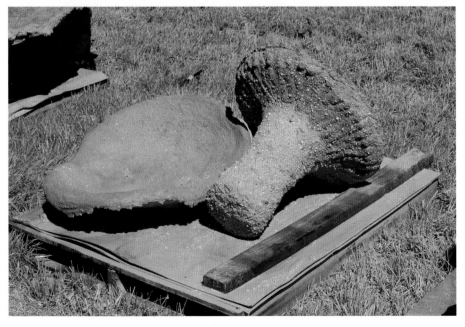

The toadstool and birdbath cleaned up and looking ready for the garden.

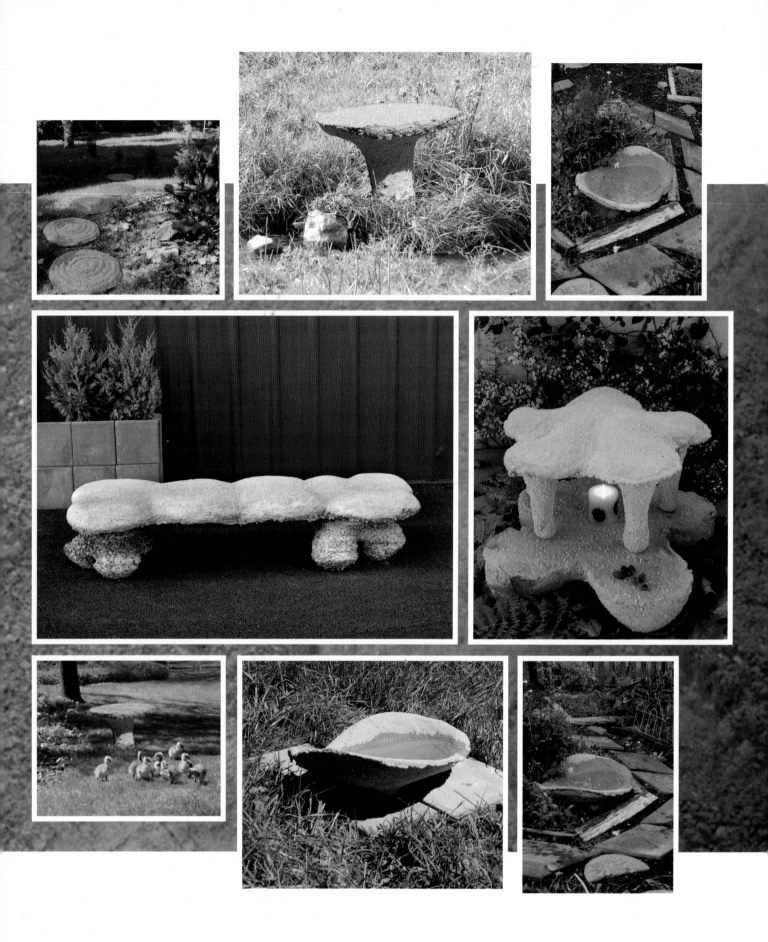